The Artist's Painting Library

WATERCOLOR PAINTING

BY WENDON BLAKE / PAINTINGS BY CLAUDE CRONEY

WATSON-GUPTILL PUBLICATIONS/NEW YORK

Copyright © 1979 by Billboard Ltd.

First published 1979 in the United States and Canada by Watson-Guptill Publications,
a division of Billboard Publications, Inc.,
1515 Broadway, New York, N.Y. 10036

Library of Congress Cataloging in Publication Data
Blake, Wendon
 Watercolor painting.
 (His The artist's painting library)
 Originally published as pt. 1 of the author's The
watercolor painting book.
 1. Water-color painting—Technique. I. Croney,
Claude. II. Title. III. Series.
ND2420.B562 1979 751.4'22 79-11962
ISBN 0-8230-5673-2

Manufactured in Japan

First Printing, 1979

10 11 12 13/97 96 95

CONTENTS

Why Paint in Watercolor? Artists who paint in watercolor are fanatical about their medium. Watercolor seems to inspire a kind of passion—once you master it—that unites watercolorists into a kind of unofficial, worldwide "society," like people who are in love with wine or sailing or horseback riding. Ask the watercolorist to define the magic of his medium and he'll probably talk about three unique qualities: transparency, speed and spontaneity.

Transparency. As it comes from the tube, watercolor is a blend of finely powdered color, called pigment; a water-soluble adhesive called gum arabic, which will glue the pigments to the watercolor paper; and just enough water to make these ingredients form a thick paste. You squeeze a dab of this paste from the tube onto the palette, load a brush with water, touch the tip of your brush to the dab of color, and swirl the brush around on the mixing area of your palette to form a pool of liquid color. That pool is essentially tinted water, as clear and transparent as the water you drink, merely darkened by a touch of color. The color on your palette is like a sheet of colored glass. You can see right through it to the white surface of the palette. And when you brush the liquid color onto the paper, the light in your studio shines through the wash, strikes the white surface of the paper, and bounces back through the layer of color like sunlight passing through stained glass. A watercolor painting is literally filled with light. That's why watercolorists love to paint the effects of light and atmosphere in outdoor subjects such as landscapes and seascapes.

Speed. As soon as the water evaporates, a stroke or wash of watercolor is dry. But that stroke or wash actually *begins* to dry as soon as the liquid color hits the paper. For a minute or two—as long as the wet color remains shiny—you can push the paint around or blend in more liquid color. But as soon as the surface of the paper begins to lose its shine, the liquid color is beginning to "set up." At that stage, you'd better stop and let it dry. From that point on, you run the danger of producing unpleasant streaks or blotches if you keep working on the damp color. If you try to introduce a brushload of fresh color into that damp surface, you're most likely to produce a distinctive kind of blotch, which every watercolorist knows and dreads—called a *fan* because of its peculiar, ragged edge. In short, watercolor forces you to be quick. You have to plan your picture carefully: decide exactly what you want to do, work with decisive strokes, then stop. Every painting is exciting—a race against time, a challenge to your decisiveness and your control of the medium. Watercolor is for people who like speed and action.

Spontaneity. Because of this rapid drying time, you're forced to wield the brush quickly and freely. Like a general planning an attack, you must do all your thinking before you sound the charge. Once the action begins, there's no turning back. As soon as the brush touches the paper, the challenge is to get the job done with a few bold, rapid strokes. This is why a good watercolor has such a wonderfully fresh, lively, spontaneous feeling. A century after the picture was painted, the viewer can still share the artist's pleasure in the sweeping action of the brush.

Permanence. Yes, a watercolor *will* last a century or more, even though it's nothing more than tinted water on a fragile sheet of paper. If you work with non-fading color—such as the colors recommended in this book—and keep your painting away from moisture, that delicate veil of color on the paper will last just as long as a tough, leathery coat of oil paint on a canvas.

Wash Demonstrations. Following a brief survey of the colors, brushes, papers, and other equipment you need for watercolor painting, this book begins by demonstrating the four basic ways of applying liquid color to paper. First, you'll see how to paint a flat wash, which means a color area that's the same density from one edge to the other. Then you'll see how to paint a graded wash, which starts out dark at one edge and gradually lightens as it reaches the other edge. You'll learn the technique called drybrush, which means working with a brush that's merely dampened with color. And finally, you'll see a demonstration of the wet-in-wet technique, which means brushing color onto a wet surface so the strokes blur and fuse.

Painting Demonstrations. These wash demonstrations are followed by a series of painting demonstrations in which Claude Croney, a master of watercolor technique, puts these four basic wash techniques to work in a series of twelve complete paintings. He starts with simple, colorful still lifes of fruit, vegetables, and flowers, since still life is the easiest way to learn how to control any painting medium. Then Croney goes outdoors to paint a variety of landscapes and coastal subjects.

Special Effects. Finally, you'll learn various technical tricks such as creating lines and textures by scratching and scraping. You'll also learn how to alter a watercolor painting by the techniques called sponging, washing, scrubbing, and lifting. And you'll learn how to mat, frame, and preserve a finished picture.

Tubes and Pans. Watercolors are normally sold in collapsible metal tubes about as long as your thumb, and in metal or plastic pans about the size of the first joint of your thumb. The tube color is a moist paste that you squeeze out onto the surface of your palette. The color in the pan is dry to the touch but dissolves as soon as you touch it with a wet brush. The pans, which lock neatly into a small metal box made to fit them, are convenient for rapid painting on location. But the pans are useful mainly for small pictures—no more than twice the size of this page—because the dry paint in the pans is best for mixing small quantities of color. The tubes are more versatile and more popular. The moist color in the tubes will quickly yield small washes for small pictures and big washes for big pictures. If you must choose between tubes and pans, buy the tubes. Later, if you want a special kit for painting small pictures outdoors, buy the pans.

Color Selection. All the pictures in this book were painted with just eleven tube colors. True, the colors of nature are infinite, but most professional watercolorists find that they can cope with the colors of nature with a dozen tube colors—or even less. Once you learn to mix the various colors on your palette, you'll be astonished at the range of colors you can produce. Six of these eleven colors are *primaries*—two blues, two reds, two yellows—which means colors that you can't create by mixing two primaries. Just two are *secondaries*—orange and green—which means colors that you *can* create by mixing other colors. You can mix a rich variety of greens by combining various blues and yellows, plus many different oranges by combining reds and yellows. So you could really do without the secondaries. But it does save time to have them. The last three colors on your palette are what painters call neutrals: two shades of brown and a gray.

Blues. Ultramarine is a dark, soft blue that produces a rich variety of greens when blended with the yellows, and a wide range of grays, browns, and browngrays when mixed with the neutrals. Cerulean blue is a light, bright blue that is popular for skies and atmospheric effects. At some point in the future, you might like to try substituting phthalocyanine blue for cerulean; phthalocyanine is more brilliant, but must be used in small quantities because it tends to dominate any mixture.

Reds. Alizarin crimson is a bright red with a hint of purple; it produces lovely oranges when mixed with the yellows, subtle violets when mixed with the blues, and rich darks when mixed with green. Cadmium red light is a dazzling red with a hint of orange, producing rich oranges when mixed with the yellows, coppery tones when mixed with the browns, and surprising darks (not violets) when mixed with the blues.

Yellows. Cadmium yellow light is bright and sunny, producing luminous oranges when mixed with the reds, and rich greens when mixed with the blues. Yellow ochre is a much more subdued, tannish yellow that produces subtle greens when mixed with the blues, and muted oranges when mixed with the reds. You'll find that both cadmiums tend to dominate mixtures, so add them just a bit at a time.

Orange. Cadmium orange is a color you really could create by mixing cadmium yellow light and cadmium red light. But it's a beautiful, sunny orange and convenient to have ready-made.

Green. Hooker's green is optional—you can mix lots of greens—but convenient, like cadmium orange. Just don't become dependent on this one green. Learn how many other greens you can mix by combining your various blues and yellows. And see how many other greens you can make by modifying Hooker's green with the other colors on your palette.

Browns. Burnt umber is a dark, subdued brown that produces lovely brown-grays and blue-grays when blended with the blues, subtle foliage colors when mixed with green, and warm autumn colors when mixed with reds, yellows, and oranges. Burnt sienna is a bright, orange-brown that produces a very different range of blue-grays and brown-grays when mixed with the blues, plus rich coppery tones when blended with reds and yellows.

Gray. Payne's gray has a distinctly bluish tone, which makes it popular for painting skies, clouds, and atmospheric effects.

No Black, No White. You may be surprised to discover that this color list contains no black or white. Once you begin to experiment with color mixing, you'll find that you don't really need black. You can mix much more interesting darks—containing a fascinating hint of color—by blending such colors as blue and brown, red and green, orange and blue. And blue-brown mixtures make far more interesting grays than you can create with black. Your sheet of watercolor paper provides the only white you need. You lighten a color mixture with water, not with white paint; the white paper shines through the transparent color, "mixing" with the color to produce the exact shade you want. If some area is meant to be *pure* white, you simply leave the paper bare.

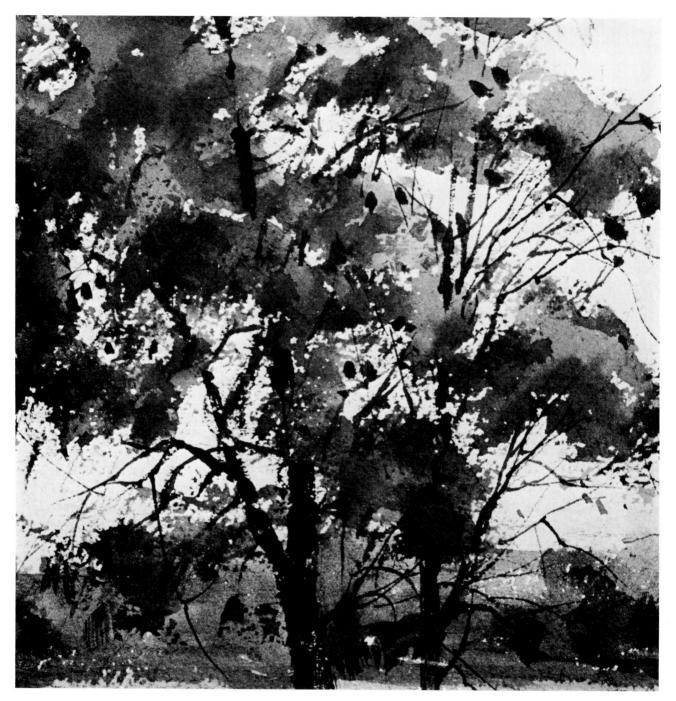

Rough Paper. The surface of your watercolor paper will have a strong influence on the character of your brushwork. On rough paper, the brushstrokes have a ragged, irregular quality, which is just right for suggesting the rough texture of treetrunks and branches and the flickering effect of leaves against a light sky. In this lifesize close-up of a section of a landscape, you can see how the texture of the paper literally breaks up the brushstrokes. If you like to work with bold, free strokes, you'll enjoy rough paper.

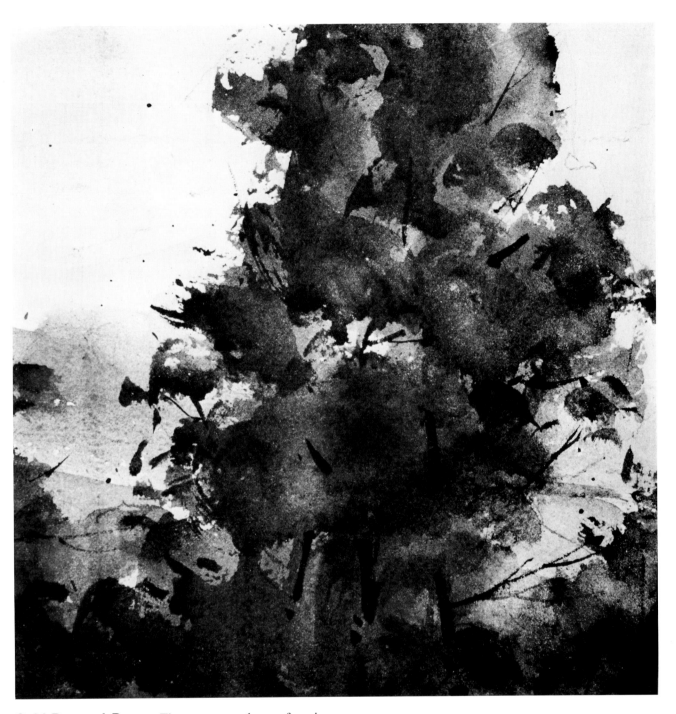

Cold Pressed Paper. The most popular surface is cold pressed—called "not" in Britain—which still has a distinct texture, but not nearly as irregular as the rough sheet. In this close-up of a tree from another painting, you can see that the liquid color goes on smoothly, and the brushstrokes don't look nearly as ragged. Cold pressed stock is the all-purpose paper that most watercolorists prefer because it's most versatile. It takes everything from big, smooth masses of color to tiny details. And you can still work with big, free strokes if that's your style.

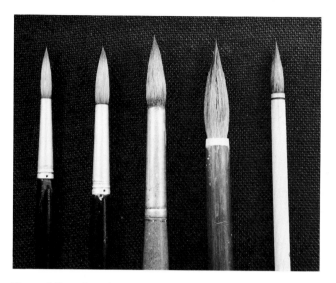

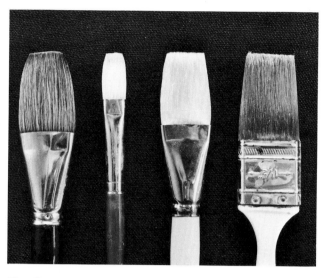

Round Brushes. When wet, a round brush should have a neat bullet shape and come to a sharp point. Here are five typical round brushes. The two at left are expensive sables. The center brush is a less expensive oxhair. At right are two inexpensive oriental brushes with bamboo handles—worth trying if you're on a tight budget. A good substitute for sable is soft white nylon.

Flat Brushes. A good flat brush, when wet, should taper to a squarish shape that curves inward toward the working end. Here, from left to right, are a large oxhair, good for big washes; a small bristle brush, like those used for oil painting, helpful for scrubbing out areas to be corrected; a large white nylon brush, a good substitute for the more expensive sable; and a nylon housepainter's brush, which you might like to try for painting or wetting big areas.

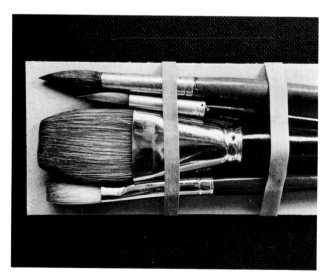

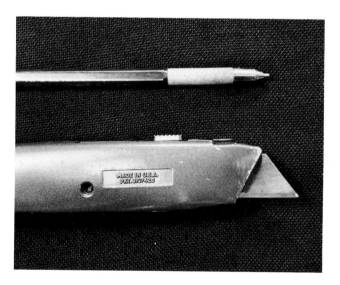

Transporting Brushes. When you're carrying your brushes from place to place, it's important to protect the delicate hairs from being squashed in your paintbox. You can cut a piece of cardboard that's just a bit longer than the longest brush; arrange the brushes carefully on the board so that they don't squash each other; then strap them down with rubber bands. For further protection, you can slip the board into a sturdy envelope or wrap it in something flexible such as a cloth or bamboo placemat secured with a couple of rubber bands.

Pencil and Knife. To sketch your composition on the watercolor paper, carry a sharp pencil with a lead that's not too dark. HB is a good grade. A mechanical pencil with retractable lead is least apt to break. For cutting paper and tape, as well as for scratching lines into your painting, a sharp knife is handy. This knife is convenient and safe because it has a retractable blade, which you replace when it gets dull.

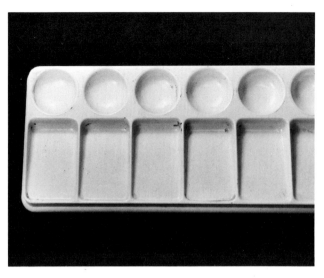

Watercolor Palette. The most versatile type of watercolor palette is made of white molded plastic or lightweight metal coated with tough white enamel paint. Along the edges of this white plastic palette are compartments into which you squeeze your tube colors. The center of the palette is a large, flat mixing area. A "lip" prevents the tube colors from running out of the compartments into the central mixing area. At the end of a painting session, you can simply mop up the mixing area with a sponge or paper towel, leaving the color in the compartments for the next session.

Studio Palette. Designed primarily for use indoors, this palette has circular "wells" into which you squeeze your tube colors, plus rectangular compartments for individual mixtures. The compartments slant down at one end so the mixtures will run downward and form pools into which you can dip your brush.

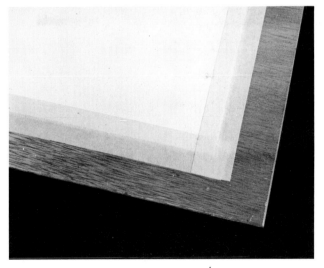

Fiberboard and Tacks. A simple way to support your watercolor paper when you're painting is to tack the sheet to a stiff piece of fiberboard. This particular piece of fiberboard is 3/4″ (about 18 mm) thick and soft enough to accept thumbtacks (drawing pins) or pushpins. Be sure to cut the board just a bit larger than the size of your watercolor paper.

Plywood and Tape. Another solution is to tape your watercolor paper to a sheet of wood—preferably plywood, which will resist warping when it gets wet. The wood will be too hard to take tacks, so use masking tape that's at least 1″ (25 mm) wide, or even wider if you can find it. A sheet of smooth hardboard will also do the job. If available, buy hardboard or plywood that's make for outdoor use; it's more resistant to moisture.

Step 1. This rock study is done in flat washes. Each wash is a series of horizontal strokes, one below the other. The strokes overlap just a bit, and you must work fast so that the strokes stay wet and blur into one another, forming an even tone. The picture begins with a pale pencil drawing. The sky and cliff are painted in a series of flat washes, each slightly darker than the one before. A pale wash covers the sky and the entire cliff area. When that's dry, a slightly darker wash covers just the cliff area. After that's dry, the darker areas are painted.

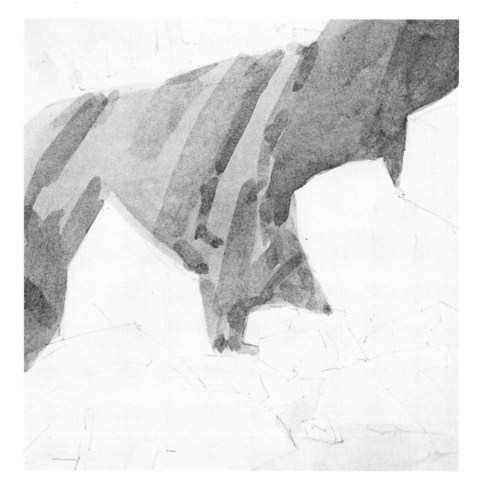

Step 2. Now the brush moves to the rocks in the foreground. A few very pale washes are painted over the light area and allowed to dry. Then the shadows are painted in with broad, straight strokes. As you'll see in a moment, the foreground shadows will eventually be much darker, but it's always best to work gradually from light to dark. One important tip: watercolor always dries paler than you expect—so get into the habit of making the liquid mixtures on your palette just a bit "too dark."

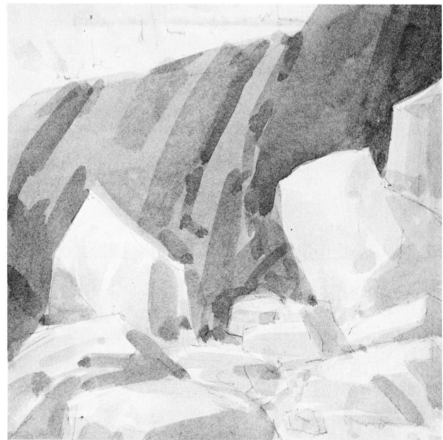

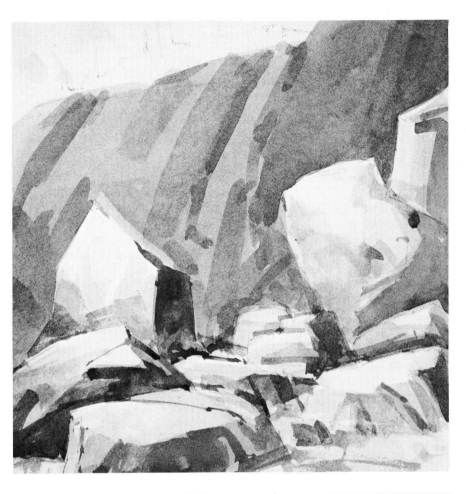

Step 3. Now the first real darks begin to appear on the shadow sides of the foreground rocks. They're still quick, straight, fairly broad strokes—no attention to precise detail yet. But these still aren't the strongest darks.

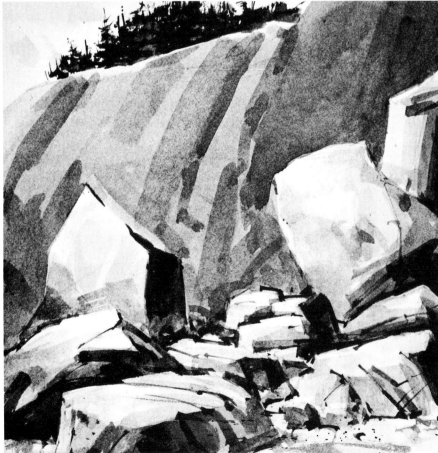

Step 4. Finally, the tip of the brush strikes in crisp, dark strokes to reinforce the shadows on the foreground rocks. This is the time to add details such as the cracks in the rocks—but not too many. The tip of the brush is also used to suggest the trees at the top of the cliff, which are painted in a series of little touches to suggest the texture of the foliage.

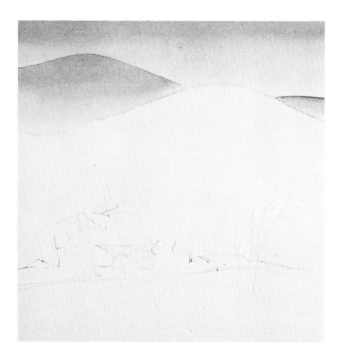

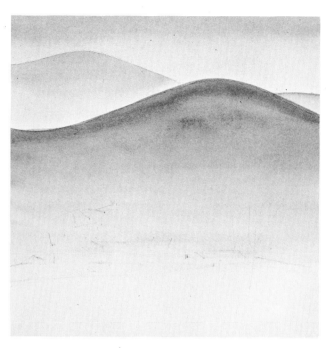

Step 1. Here's how hills are done in graded washes—tones that move from dark to light. The sky begins with one or two horizontal strokes of dark color, followed by several strokes of paler color containing more water. The wet strokes blur together. When the sky is dry, the distant hills are done in the same way. The near hill and the foreground remain bare paper.

Step 2. Now the nearest, biggest hill is done in the same way as the sky and far hill. The topmost strokes are quite dark; thus the more distant hill at the horizon seems farther away. The immediate foreground is still bare paper.

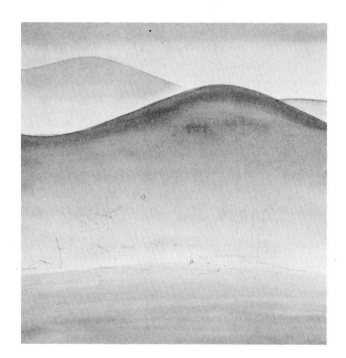

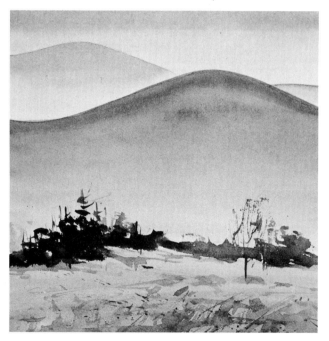

Step 3. Work begins on the immediate foreground. You can see that it's a rather streaky, graded wash. The strokes are applied very freely so they don't quite blend, and the strokes in the immediate foreground are only a little darker than those beyond. As you'll see in the next step, the entire foreground will have an irregular texture.

Step 4. As in the previous demonstration, the darks and the details are saved for the very end. Now the tip of the brush suggests the dark trees at the foot of the hill plus the grasses and weeds at the very bottom of the picture.

Step 1. The wet-in-wet technique means painting on wet paper, so your strokes soften and blur. But a wet-in-wet passage looks most effective when contrasted with more precise washes. So this picture begins with a series of flat washes for the woods at the top, painted wash over wash like the rock study you've just seen. A few big strokes suggest light and shadow.

Step 2. Now the woods are completed with more precise, slender strokes to suggest treetrunks and more shadows. For precise work like this, you can either use a smaller brush or the tip of a very large brush. The water area is still bare paper.

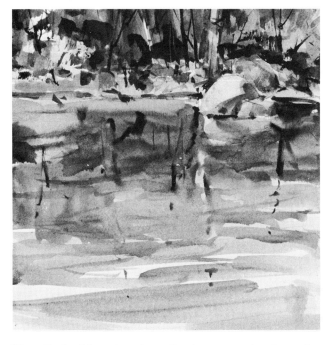

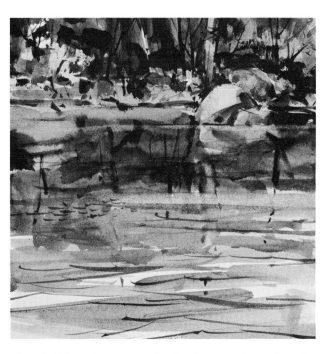

Step 3. At this point, the reflections are painted wet-in-wet. Pale, horizontal strokes suggest the water. It's important to wait a moment for the wash to settle into the paper. Then, while the underlying wash is still wet and shiny, the brush goes back in with darker strokes that blur and suggest the reflections just below the shoreline.

Step 4. When the water and reflections are dry, a few ripples and streaks are added with a small brush. Note that a wet-in-wet passage always dries *much* lighter than you expect, so the color on your brush should always be quite dark.

Step 1. Now you'll see how dry-brush is used to paint the rough texture of a forest scene. Over a simple pencil drawing of the main shapes, a pale tone is quickly brushed in for the distant sky, leaving bare paper for the two light treetrunks just left of center. While the sky wash is still wet, a few darker strokes are added to suggest the distant woods. These darker strokes blur into the wet sky wash.

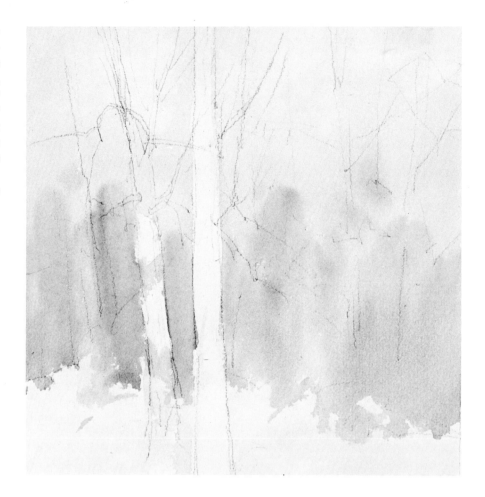

Step 2. The tip of the brush adds a few fast, decisive strokes for the darker treetrunks as well as some branches. It's a good idea to place these darks early, so that you don't lose track of them among the mass of drybrush strokes that will come next.

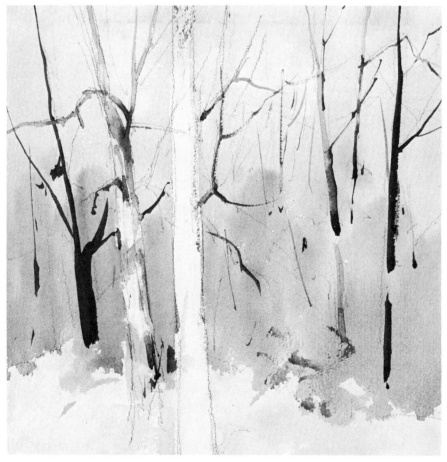

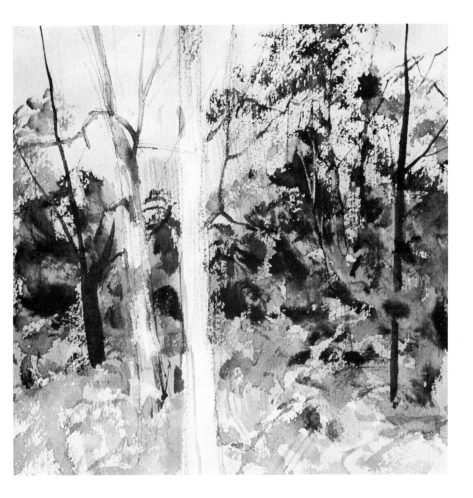

Step 3. Now the drybrush work begins. The brush is damp, not wet—lots of color, but not too much water. If the brush is too wet, wipe it on a paper towel. Now the brush is skimmed over the paper, leaving color on the ridges and skipping over the valleys. If you press harder, you'll deposit more color, but the strokes will still have a broken, irregular look, with flecks of paper showing through. The darks in the center are placed with quick, rough strokes. If some strokes look too dark and ragged, they can be softened with some strokes of liquid color, as you see in the center. Notice the pale drybrush strokes in the immediate foreground.

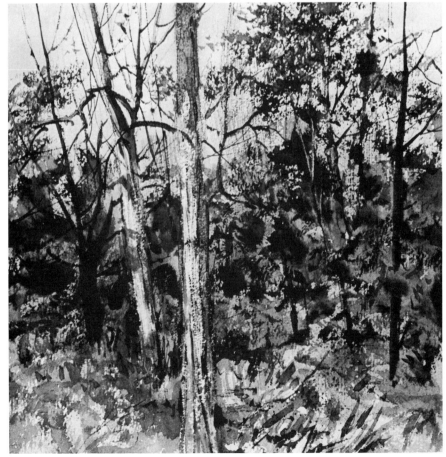

Step 4. Drybrush strokes gradually build up the darks of the woods, the foliage against the sky, and the grasses and weeds in the foreground. Finally, the tip of the brush suggests the texture of the central treetrunk with slender strokes—and adds details such as more branches, twigs, and foreground weeds.

Studio Setup. Whether you work in a special room you've set aside as a studio or just in a corner of a bedroom or a kitchen, it's important to be methodical about setting up your painting equipment. Let's review the basic equipment you'll need and let's see how this equipment should be arranged.

Brushes. It's best to buy just a few brushes—and buy the best you can afford. You can perform every significant painting operation with just four softhair brushes, whether they're expensive sable, less costly oxhair or squirrel, soft white nylon, or some blend of inexpensive animal hairs. All you really need are a big number 12 round and a smaller number 7 round, plus a big 1″ (25 mm) flat and a second flat about half that size.

Paper. The best all-purpose watercolor paper is mouldmade 140 pound stock in the cold pressed surface (called a "not" surface in Britain) which you ought to buy in the largest available sheets and cut into halves or quarters. The most common sheet size is 22″ x 30″ (56 cm x 76 cm). Later, you may want to try the same paper in a rough surface.

Drawing Board. The simplest way to support your paper while you work is to tack or tape the sheet to a piece of hardboard cut just a little bigger than a full sheet or half sheet of watercolor paper. You can rest this board on a tabletop, perhaps propped up by a book at the back edge so that the board slants toward you. You can also rest the board in your lap or even on the ground. Art supply stores carry more expensive wooden drawing boards to which you tape your paper. At some point, you may want to invest in a professional drawing table with a top that tilts to whatever angle you find convenient. But you can easily get by with an inexpensive piece of hardboard, a handful of thumbtacks or pushpins, and a roll of masking tape 1″ (25 mm) wide to hold down the edges of your paper.

Palette or Paintbox. Some professionals just squeeze out and mix their colors on a white enamel tray—which you can probably find in a shop that sells kitchen supplies. The palette made *specifically* for watercolor is white metal or plastic, with compartments into which you squeeze tube colors, plus a mixing surface for producing quantities of liquid color. For working on location, it's convenient to have a metal watercolor box with compartments for your gear. But a toolbox or a fishing tackle box—with lots of compartments—will do just as well. If you decide to work outdoors with pans of color, buy an empty metal box

equipped to hold pans, then buy the selection of colors listed in this book: don't buy a box that contains pans of color preselected by the manufacturer.

Odds and Ends. You'll need some single-edge razor blades or a knife with a retractable blade (for safety) to cut paper. Paper towels and cleansing tissues are useful, not only for cleaning up, but for lifting wet color from a painting in progress. A sponge is excellent for wetting paper, lifting wet color, and cleaning up spills. You'll obviously need a pencil for sketching your composition on the watercolor paper before you paint: buy an HB drawing pencil in an art supply store or just use an ordinary office pencil. To erase the pencil lines when the watercolor is dry, get a kneaded rubber (or "putty rubber") eraser so soft that you can shape it like clay and erase a pencil line without abrading the delicate surface of the paper. Find three wide-mouthed glass jars big enough to hold a quart or a liter of water; you'll find out why in a moment. If you're working outdoors, a folding stool is a convenience—and insect repellent is a *must*!

Work Layout. Lay out your supplies and equipment in a consistent way so that everything is always in its palce when you reach for it. Directly in front of you is your drawing board with your paper tacked or taped to it. If you're right-handed, place your palette and those three wide-mouthed jars to the right of the drawing board. In one jar, store your brushes, hair end up; don't let them roll around on the table and get squashed. Fill the other two jars with clear water. Use one jar of water as a well from which you draw water to mix with your colors; use the other for washing your brushes. Keep the sponge in a corner of your palette and the paper towels nearby ready for emergencies. Line up your tubes of color some place where you can get at them quickly—possibly along the other side of your drawing board—when you need to refill your palette. Naturally, you'd reverse these arrangements if you're left-handed.

Palette Layout. In the excitement of painting, it's essential to dart your brush at the right color instinctively. So establish a fixed location for each color on your palette. There's no one standard arrangement. One good way is to line up your colors in a row with the *cool* colors at one end and the *warm* colors at the other. The cool colors would be gray, two blues, and green, followed by the warm yellows, orange, reds, and browns. The main thing is to be consistent so that you can find your colors when you want them.

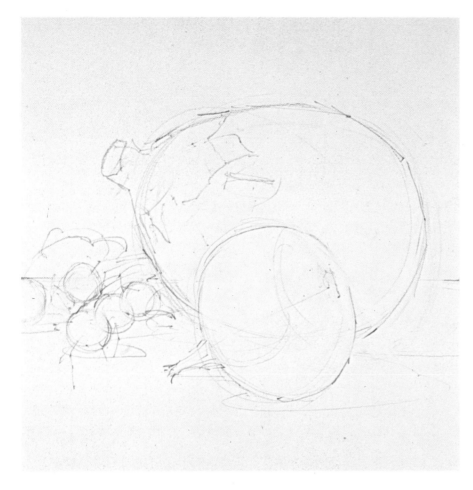

Step 1. To learn how to model forms—to get a sense of three-dimensional roundness—it's best to start out with some still-life objects from the kitchen, such as this arrangement of an eggplant, an onion, and some radishes. Begin with a simple drawing. You needn't be too precise in drawing your lines, since you're going to erase them with kneaded rubber (or putty rubber) after the complete painting is dry.

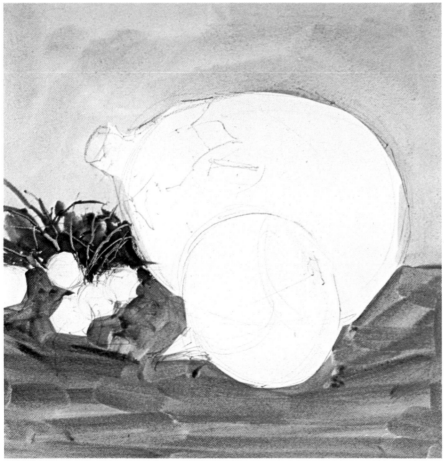

Step 2. The background and the tabletop are painted with big, free strokes. The background is ultramarine blue mixed with a touch of burnt sienna. The tabletop is mostly burnt umber, plus a bit of cerulean blue. The greens behind the radishes are Hooker's green and burnt sienna, painted with a small, round brush. The stems are scraped out with the tip of the brush handle while the color is still wet.

Step 3. The rounded form of the eggplant is brushed in with curving strokes—a blend of alizarin crimson, ultramarine blue, and burnt umber. Some strokes are darker than others and they all blur together, leaving a piece of bare paper for the highlight. The onion is painted with a mixture of yellow ochre, cadmium orange, and a touch of cerulean blue, with all the strokes blurring together, wet-in-wet. The dark spots on the onion are burnt umber, brushed in while the underlying color is still wet. The green on the eggplant is cadmium yellow, cerulean blue, and yellow ochre.

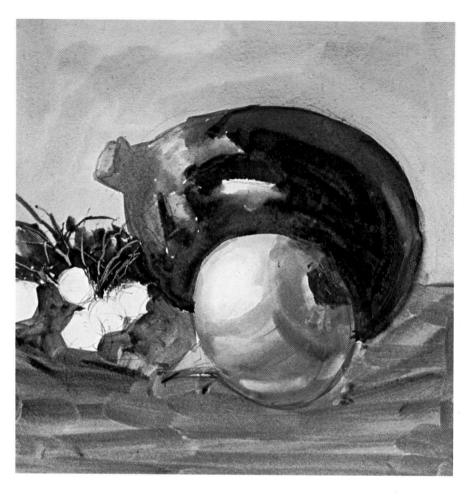

Step 4. The radishes are modeled with the short, curving strokes of a small, round brush—a blend of cadmium yellow, cadmium red, and alizarin crimson for the bright tones, then Hooker's green for the dark touches. The dark greens on the tip of the eggplant are also Hooker's green darkened with a touch of cadmium red.

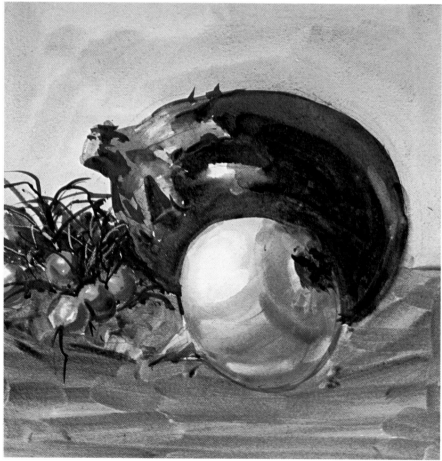

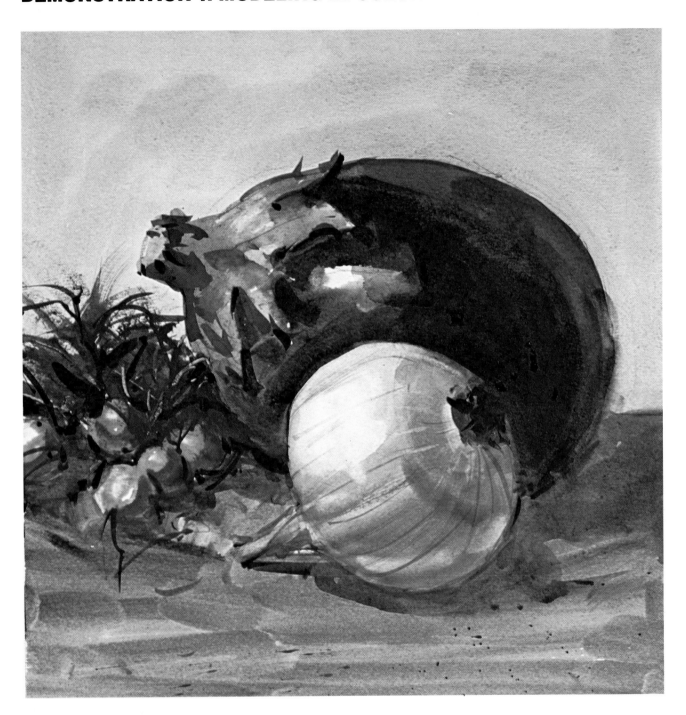

Step 5. Finally, cast shadows are added beneath the egg-plant, onion, and radishes in a dark mixture of burnt umber and ultramarine blue. Some dark touches are added to the green tip of the eggplant, at both ends of the onion, and be-hind the radishes with a mixture of Hooker's green and alizarin crimson. Some lines of burnt umber are added to the onion, and some light lines are scratched out with the corner of a sharp blade. Going back to the green mixture in Step 2, some drybrush strokes are added behind the radishes. As you can see, the main point is to follow the forms. The brushstrokes on the vegetables are rounded, like the shapes of the vegetables themselves. And the strokes of the table are horizontal, like the surface of the table.

Step 1. Some rough-textured object like this old, dead treestump is ideal for developing your skill with drybrush. This may also be a good opportunity to try out rough paper, in contrast to the cold pressed (or "not") paper used in the previous demonstration. The preliminary pencil drawing defines the general shape of the treestump, indicates some of the bigger cracks, and suggests some roots that will be painted out later because they're distracting.

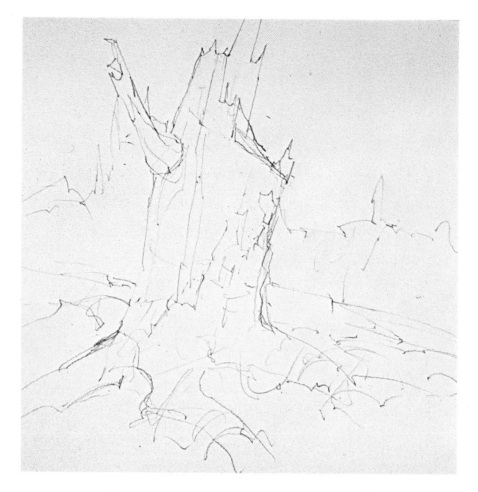

Step 2. In a landscape, it's usually best to start with the sky, painting it with a large flat or round brush. The sky mixture here is ultramarine blue, alizarin crimson, and yellow ochre. Then you can work on the shapes along the horizon, which happen to be trees in this case—a mixture of Hooker's green and burnt umber, with a bit of Payne's gray. The grass is Hooker's green, yellow ochre, and burnt sienna. This completes the background for the treestump. The lines in the distant trees are scratched with the tip of a brush handle while the color is wet.

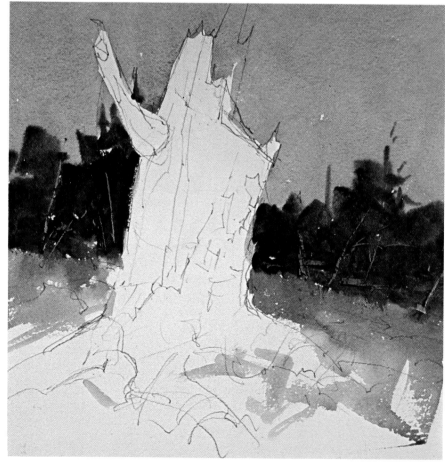

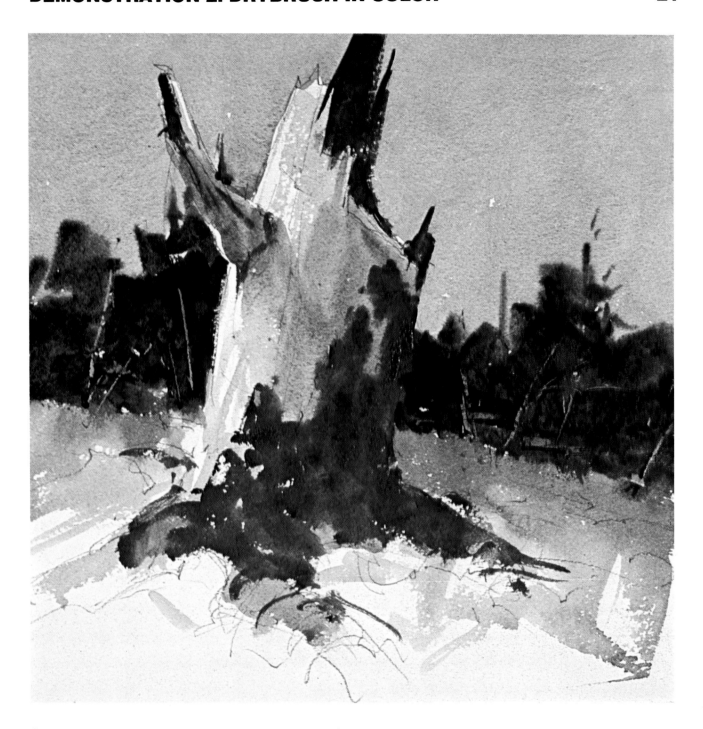

Step 3. Now it's time to work on the main color areas of the treestump itself. It's usually best to work from light to dark. The lighter tones of the wood are burnt sienna and ultramarine blue, leaving some bare paper on the left side of the stump for the lights. This same mixture is used for the shadow side of the broken branch. While the light tone is still damp, a dark mixture of Hooker's green and burnt umber is added to the right side of the stump, so the dark and light tones fuse slightly. This mixture is also used for the other darks on the stump. At this point, the brush carries a lot of color, but it's not too wet; thus the strokes have a drybrush feeling—particularly the darks at the top of the stump.

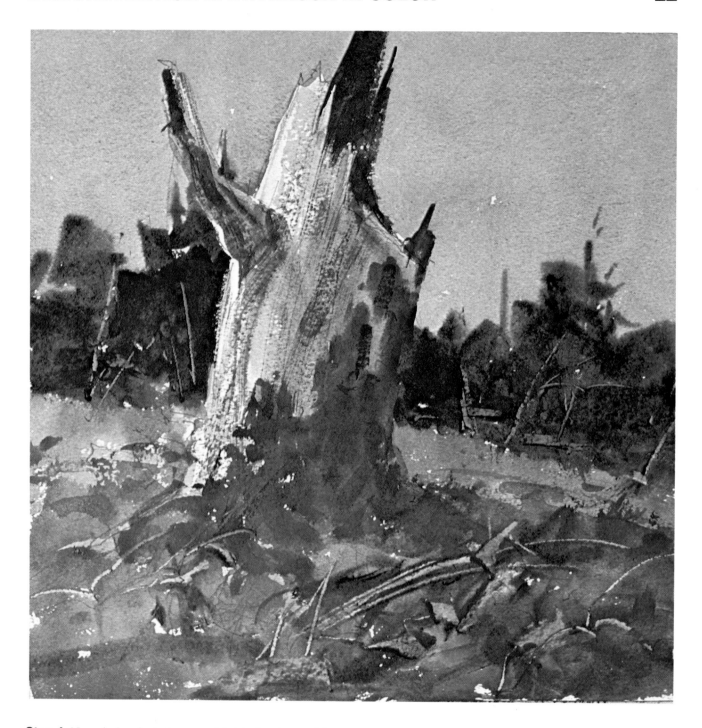

Step 4. Now drybrush strokes are added to the stump, following the upward direction of the form and suggesting the roughness of the dead, weathered wood. These strokes are a mixture of cerulean blue and burnt sienna. The dead weeds in the foreground are painted roughly with a big brush—a mixture of yellow ochre, burnt sienna, and burnt umber— with one wet stroke blurring into the next. While the foreground color is still wet, it's fun to scrape into the color with the tip of a brush handle to suggest individual weeds. If you look closely, you can see some drybrush strokes suggesting the rough texture of the ground.

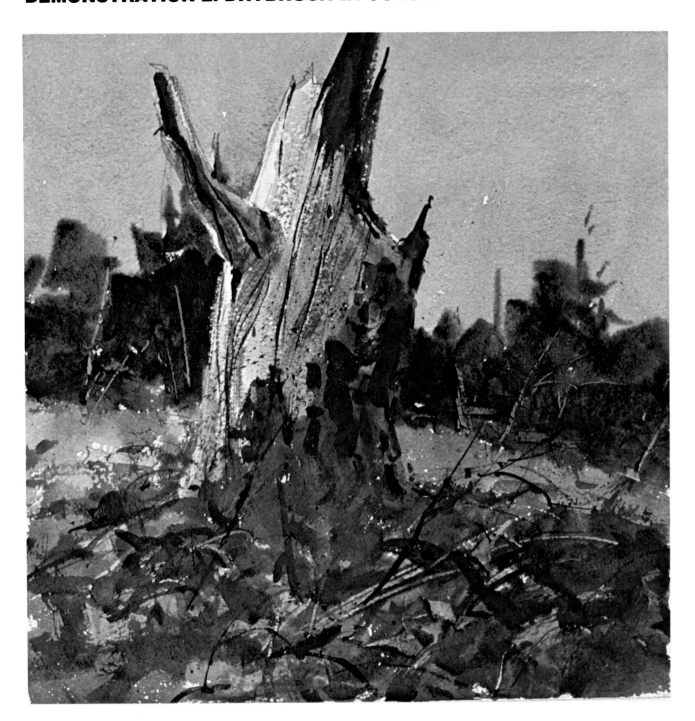

Step 5. Drybrush strokes of burnt umber are added to the foreground. More darks are added to the stump with a mixture of alizarin crimson and Hooker's green. This mixture is used for the very slender strokes and additional drybrush textures on the light part of the stump. The sharp corner of a blade is used to scrape out some light lines next to the dark ones, strongly emphasizing the texture of the wood. Finally, a few touches of cadmium red are added at the base of the stump, within the dark shadows at the top of the stump, and inside the cracked branch. The finished painting is actually a combination of many different effects. The sky is a flat wash. The distant trees are painted wet-in-wet into the sky. Drybrush is used selectively, mainly on the stump and in the foreground.

Step 1. The rounded forms of fruit always make an excellent subject for a still life— good practice for developing your skills with the brush. This casual arrangement of grapefruit, apples, and plums begins with a simple pencil drawing that indicates the rounded shapes of the fruit, plus the bowl and the dividing line between the tabletop and the background wall. The background is painted with a mixture of cerulean blue, yellow ochre, and burnt sienna, with more blue in some places and more brown or yellow in others. The same colors are used on the underside of the bowl, with more yellow ochre.

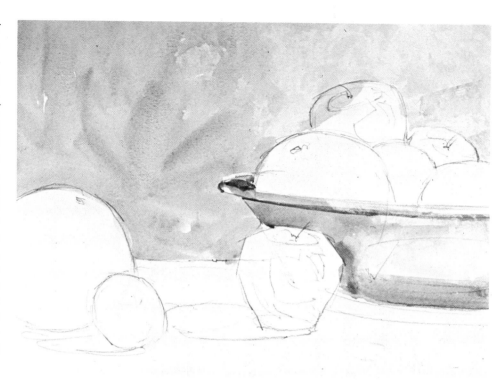

Step 2. The light side of the grapefruit is painted with cadmium yellow, plus some yellow ochre and a touch of cerulean blue on the shadow side. While the light washes are still wet, the dark strokes are added so that the dark and light strokes blur together a bit. Notice how the strokes curve to follow the rounded forms.

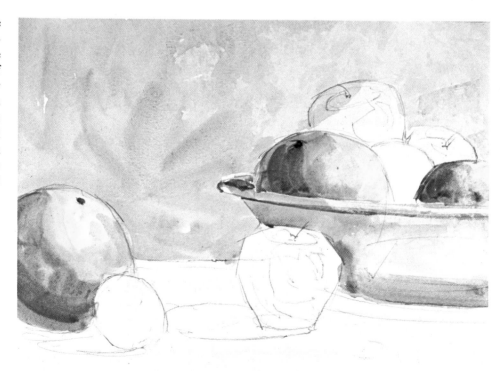

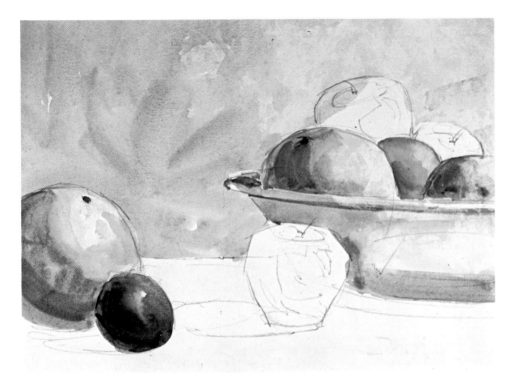

Step 3. The orange in the bowl, just behind the two grapefruit, starts with a mixture of cadmium yellow and cadmium orange. An extra dash of cadmium orange is added to the top while the first wash is still wet, and a little Hooker's green is brushed into the wet wash to suggest a shadow farther down. The plum is mainly ultramarine blue and alizarin crimson, with a hint of yellow ochre. A bit of bare paper is left for the highlight. The lighter side of the plum is painted with more water in the mixture, the shadow side with less. The two tones blend together, wet-in-wet.

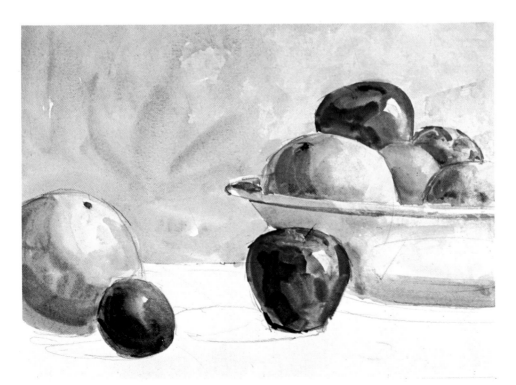

Step 4. The lighter sides of the apples are painted with cadmium red and a little cadmium yellow, adding more cadmium red and alizarin crimson to the shadow side. The darkest touches of shadow include a little Hooker's green. The dark touches are added while the lighter strokes are still slightly wet. The green at the top of the apple is Hooker's green plus a little cadmium yellow. The paler apple at the back of the bowl is painted with the same mixtures, but with more water.

Step 5. Now it's time to "anchor" the fruit to the horizontal surface of the table, which is painted with a large, flat brush carrying a fluid mixture of Hooker's green and burnt sienna. You can see that the brushstrokes are rather irregular, some containing more green and some containing more brown. More strokes are added to the background wall with the same big brush; the free, erratic strokes carry mixtures of cerulean blue, yellow ochre, and burnt sienna, some strokes bluer and some browner than others.

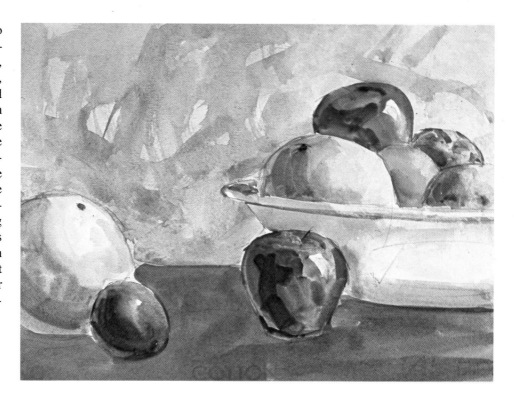

Step 6. Shadows on the table are added with a dark mixture of burnt umber and Hooker's green, carefully painted with a small, round sable. A few strokes are added to the tabletop to suggest the wood texture. Then more texture is added to the wall and the tabletop by a technique called spattering: the brush is dipped into wet color, which is then thrown onto the painting surface with a whipping motion of the wrist, spattering small droplets of paint. Stems are added to the apples—a blackish blend of Hooker's green and alizarin crimson.

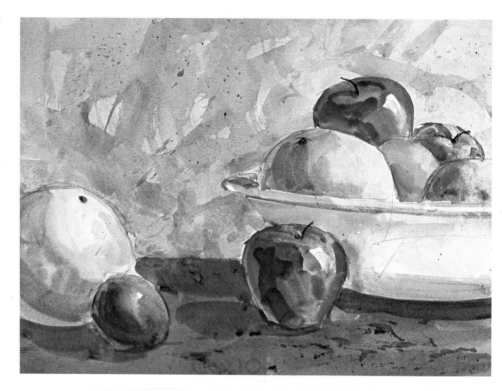

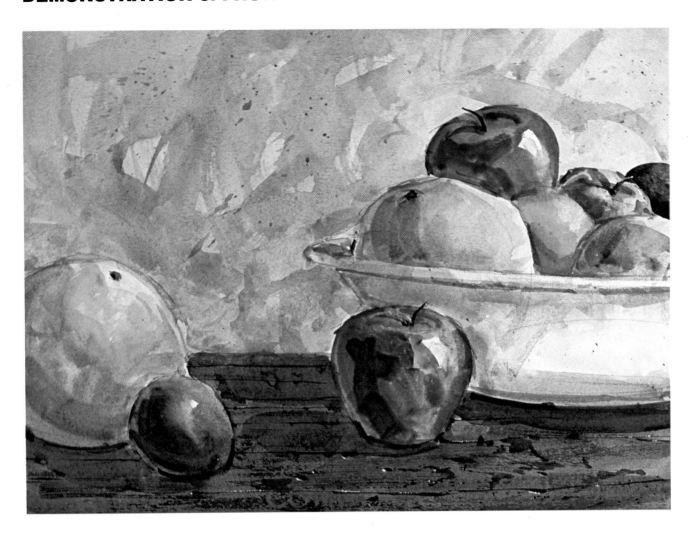

Step 7. The picture seems to need another dark note, so a second plum is added to the bowl, using the same mixtures as the plum painted in Step 3. Finally, details are added with the tip of a small, round brush. Lines are painted on the tabletop to suggest cracks. The same brush is used for the drybrush textures on the table. The corner of a sharp blade scratches some light lines next to the dark ones. Dark lines are added to sharpen the edges of the fruit in the bowl, beneath the bowl, and beneath the fruit on the table—to make them "sit" more securely. These darks aren't black, but a mixture of Hooker's green and alizarin crimson, like the apple stems. Finally, the shadow on the side of the bowl is darkened slightly with cerulean blue, yellow ochre, and burnt sienna. Notice the warm reflection of the apple in the shiny side of the bowl—painted all the way back in Step 1!

Step 1. Perhaps the most delightful indoor subject is a vase of flowers, preferably in some casual arrangement like this one. Here, the background tone is a mixture of ultramarine blue, yellow ochre, and a touch of alizarin crimson. When the background is dry, the general shapes of the flowers are painted in various mixtures of cadmium orange, cadmium red, and alizarin crimson, with the shapes blurring into one another, wet-in-wet. With the flowers just partially dry, the leaves are quickly added, sometimes blurring into the edges of the flowers. The leaves are Hooker's green and burnt umber.

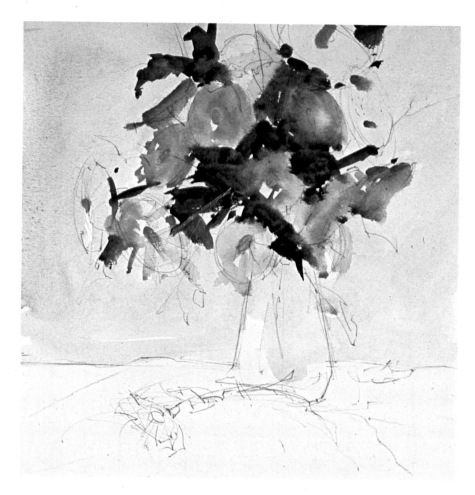

Step 2. Cooler flowers are added with a mixture of cerulean blue and alizarin crimson. The yellow centers of the flowers are yellow ochre and cadmium yellow. So far, the brushwork is broad and free, with no attention to detail—the flowers and leaves are just colored shapes.

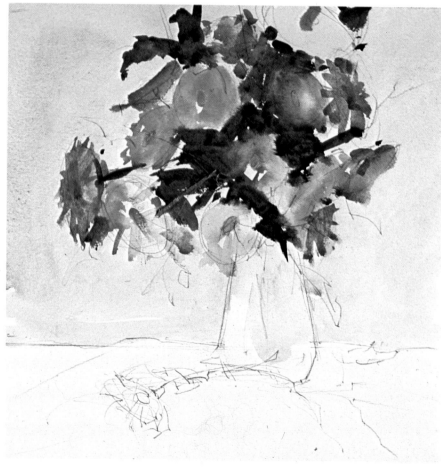

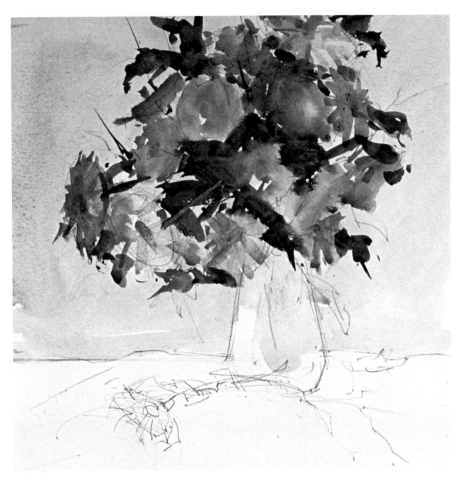

Step 3. With the main shapes of the flowers and leaves blocked in, less important shapes are added around the edges—more flowers at the top and bottom, more leaves at the bottom and the right. The leaves are the same mixture of Hooker's green and burnt umber. The new, pale flowers are yellow ochre and cerulean blue in the light areas, Hooker's green, yellow ochre, and ultramarine blue in the darker areas.

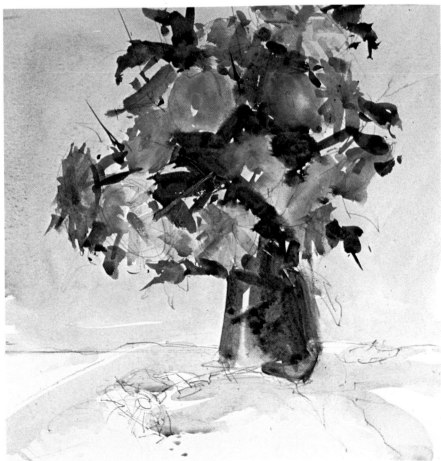

Step 4. Now it's time to begin work on the glass vase. The glass and the water within it have no color of their own, but simply reflect the color of their surroundings. Thus, the vase takes on the color of the dark stems in the water and the dark leaves above. The strokes on the vase are various mixtures of cerulean blue and burnt sienna, with a hint of Hooker's green, all painted into one another while they're still wet. A patch of light paper is left for a highlight, and a softer light is created by blotting up some wet color with a paper towel. The folds on the tabletop are suggested with a mixture of cerulean blue and burnt sienna.

Step 5. A flower and a leaf are added to the tabletop. The petals are a mixture of cadmium orange, cadmium red, and alizarin crimson, painted with a small, round brush. The light green is cadmium yellow, yellow ochre, and Hooker's green, while the dark green is Hooker's green and a touch of alizarin crimson. Cool shadows are added beneath the flower and under the leaves with cerulean blue and a little burnt sienna.

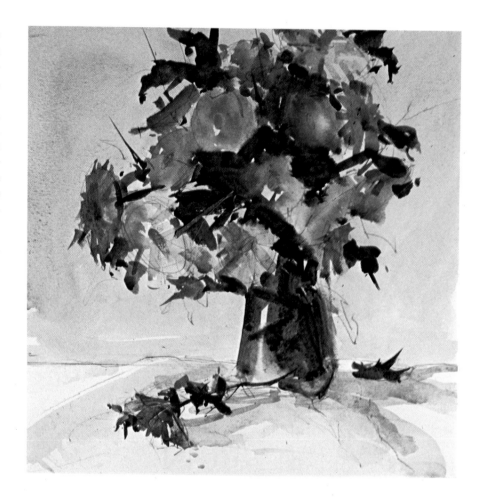

Step 6. The main colored shapes are completed. Now come the details. Alizarin crimson and Hooker's green make a good dark tone for painting the slender lines that suggest the petals of the flowers and the vase. The same mixture is used for adding more stems and a few more leaves.

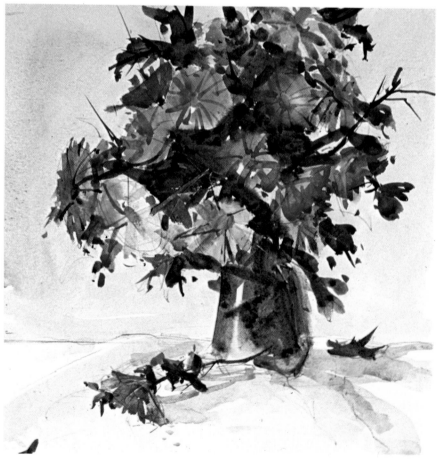

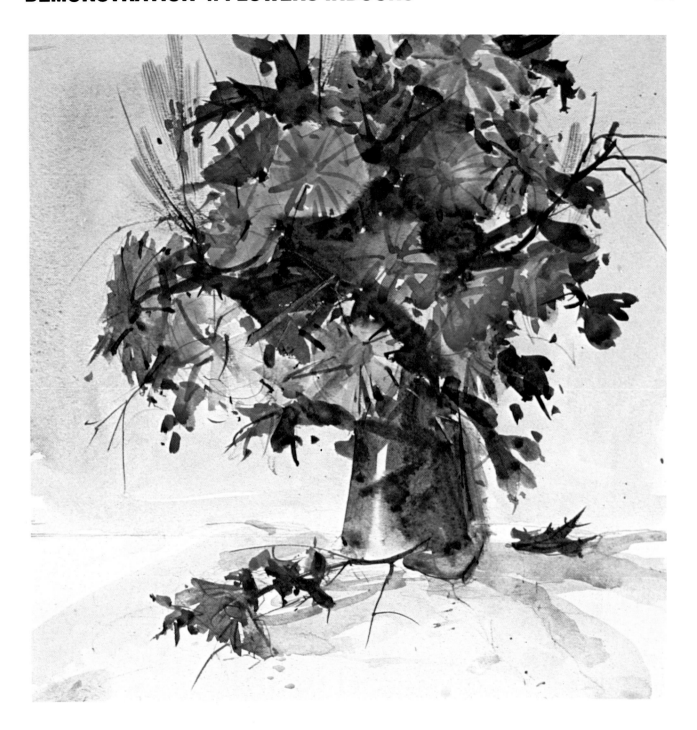

Step 7. In the final stage, you look carefully at the picture and add just a few more details, very selectively. Here you can see even more twigs at the right and left sides of the bouquet. More twigs are also added to the stem of the flower on the tabletop, and a fernlike shape is added at the upper left. All these dark notes are mixtures of Hooker's green and burnt umber or Hooker's green and alizarin crimson. Just a bit of spatter in the immediate foreground suggests some fallen petals or bits of bark from the twigs. In painting the delicate, graceful forms of flowers, it's important not to be *too* careful. Paint them as freely and broadly as you paint trees. And don't get carried away with too much detail. A little detail goes a long way.

Step 1. Having painted a bouquet of flowers indoors, why not try painting flowers in their natural outdoor setting? This demonstration begins with a fairly precise drawing of the main flower shapes, plus a few simple lines for the rocks and the lighter mass of flowers in the distance. The rock forms are painted in a series of flat washes—a mixture of alizarin crimson, ultramarine blue, and yellow ochre, with each successive wash getting a bit darker. The warm tone on the flowers is a liquid "mask" that repels paint and keeps the paper pure white. You'll see why later.

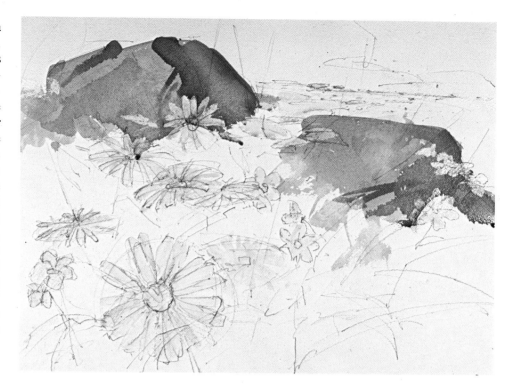

Step 2. Now the whole picture is covered with big, splashy strokes to indicate the large color areas. The lighter greens are mixtures of cadmium yellow, Hooker's green, and burnt sienna. The darker greens are Hooker's green and burnt umber. The splashes of hot color are mixtures of cadmium orange, cadmium red, and alizarin crimson. Some color overlaps the pale shapes of the flowers but doesn't soak into the paper because these areas are protected by the dried masking liquid—or frisket—which you can buy in an art supply store that specializes in materials for graphic designers.

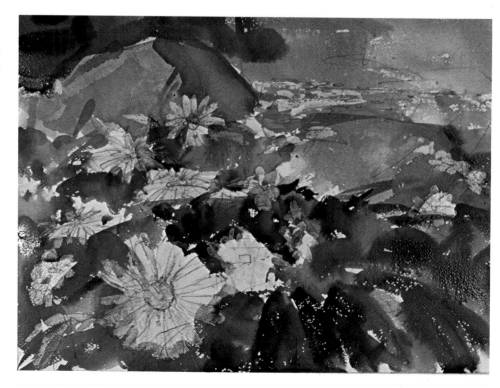

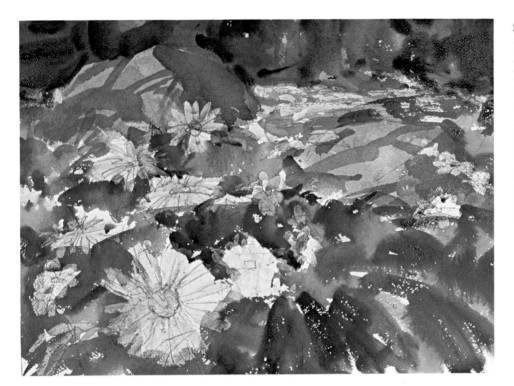

Step 3. The background at the top of the painting is darkened with strokes of Hooker's green blended with burnt umber and ultramarine blue. Notice how the various dark strokes overlap and blur together, wet-in-wet. The shadows on the rocks are painted with the same mixture used in Step 1. So far, everything has been done with a big, round brush.

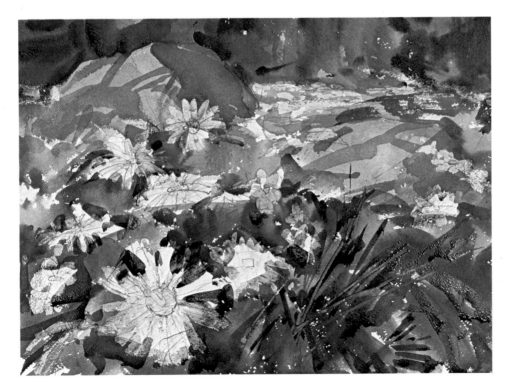

Step 4. Now more work is done in the foreground, where slender, dark strokes are added with a small, round brush to suggest grasses and weeds. You can see these in the lower right, where the dark strokes are a mixture of Hooker's green, burnt umber, and ultramarine blue. While the paint is still damp, the lighter lines in the lower right are scraped in with the tip of the brush handle.

Step 5. The time has come to remove the masking liquid from the flowers in the foreground and from the mass of flowers beyond the rocks. You can peel away the frisket with your fingers; it comes off like a thin sheet of rubber. The flowers are now ready for you to paint.

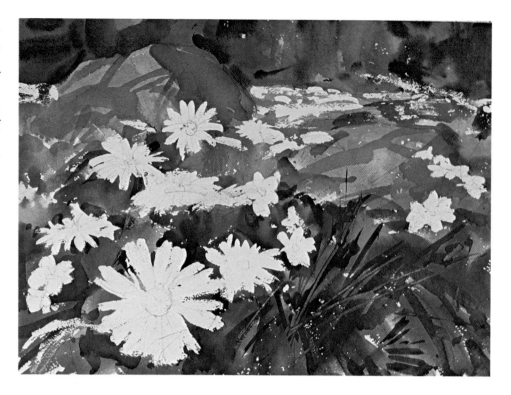

Step 6. The violet flowers are painted with a mixture of ultramarine blue and alizarin crimson. The shadows on the white flowers are a very pale mixture of yellow ochre and cerulean blue. The centers of the white flowers are yellow ochre with a touch of cadmium orange and cerulean blue. The brilliant reddish flower just left of center is cadmium red and alizarin crimson. Touches of these mixtures are added to the mass of flowers beyond the rocks.

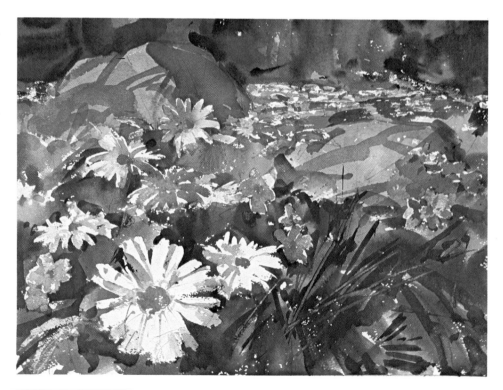

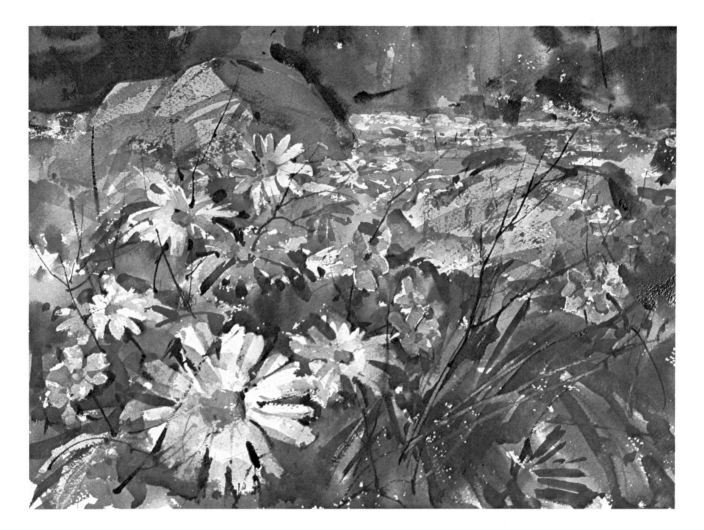

Step 7. Cool shadows are washed over the flowers in the foreground—a mixture of ultramarine blue, burnt sienna, and yellow ochre. The edges of some of the white flowers are softened and blurred by scrubbing them with a wet bristle brush, then blotting them with a paper towel. You can see this clearly in the smaller white flower at the center of the picture. With a small, round brush, dark strokes are added around the nearby flowers to sharpen their shapes—the darks are a mixture of Hooker's green and alizarin crimson. The same mixture is used to add crisp, slender strokes for blades of grass that stick up through the masses of flowers, particularly in the left side of the painting. The same dark mixture is used to add a few dark strokes to the rocks, and the brush is skimmed lightly over the rocks to add some drybrush textures. For these very slender lines, it's helpful to have a skinny brush used by signpainters—called a rigger. If you squint at the finished painting, you'll make an interesting discovery: the painting consists mostly of dark, rather subdued tones, and there are really very few bright colors. These bright colors have so much impact precisely because they're surrounded by more somber hues.

Step 1. Look for other outdoor "still lifes" like this treetrunk fallen across a stream. The initial pencil drawing defines the shape of the trunk very carefully, indicates a couple of large cracks in the trunk, but simply suggests the shapes of the surrounding weeds and the reflection of the trunk in the water. These pencil lines shouldn't be followed *too* carefully when you start to paint.

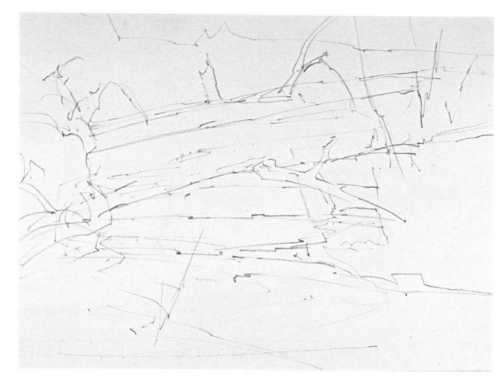

Step 2. The background is painted first to define the shape of the tree as precisely as possible. The narrow strip of sky is painted right down to the trunk with Payne's gray and yellow ochre. Before the sky tone dries, the mass of distant trees is brushed in with a mixture of Hooker's green, burnt umber, and Payne's gray. The tone beneath the trunk is ultramarine blue and a little burnt umber. The whole job is done with a big, round brush, using the tip along the edge of the treetrunk.

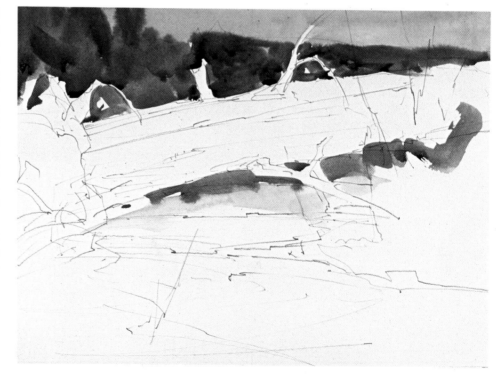

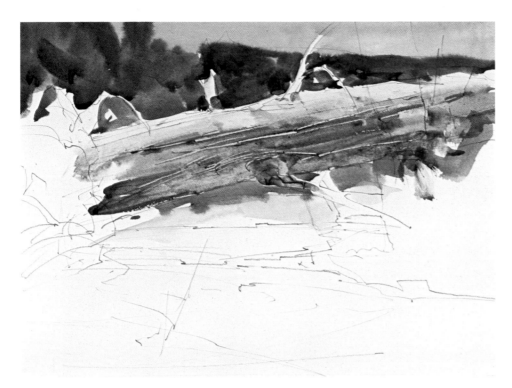

Step 3. Work begins on the top of the trunk, leaving bare paper at the edge and then starting with a very pale wash of cerulean blue and burnt sienna that is mostly water. The shadow on the trunk is a darker version of the same mixture, with more blue in some strokes and more brown in others. While the color is still wet, the white lines are scratched in with the tip of the brush handle.

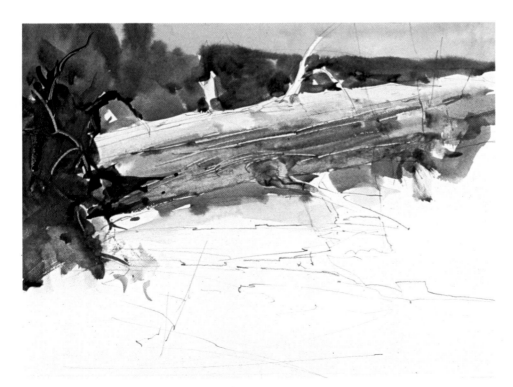

Step 4. The base of the tree (at your left) is painted with a dark mixture of alizarin crimson and Hooker's green, plus some extra strokes of cadmium red that melt away into the dark. You can see more scratches made in the wet color by the brush handle. You can also try doing this with your fingernail or with the corner of a discarded plastic credit card.

Step 5. The masses of weeds to the right are painted with various mixtures of Hooker's green, burnt sienna or burnt umber, Payne's gray, and sometimes a touch of cadmium yellow to brighten the green. You can see that it's not one uniform mixture, but a number of overlapping strokes of several mixtures. The same mixtures are used on the left. And more light scratches are made into the wet color. So far, everything has been done with a big, round brush.

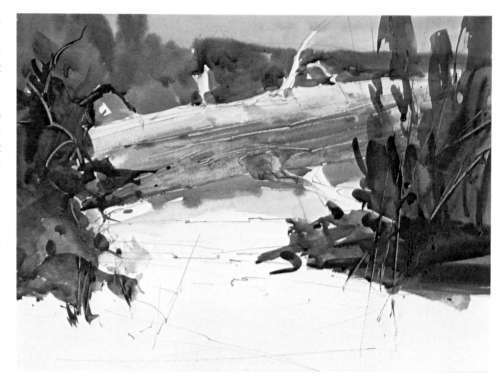

Step 6. The water comes next. First, the general tone of the water is indicated with streaky strokes of Payne's gray and yellow ochre. Then the dark reflection on the tree is painted with a mixture of burnt sienna and cerulean blue. The other reflections in the foreground are a mixture of Hooker's green, burnt umber, and Payne's gray. This mixture is also used for the ripples. Note that a bit of the paper is left bare to suggest the light on the water.

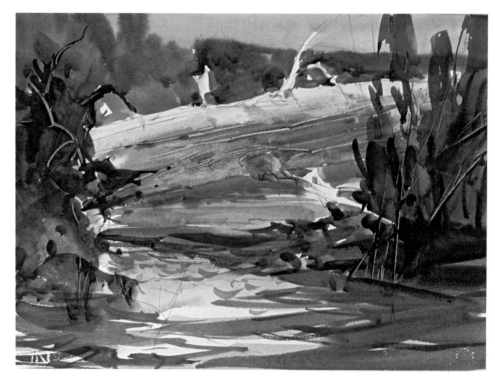

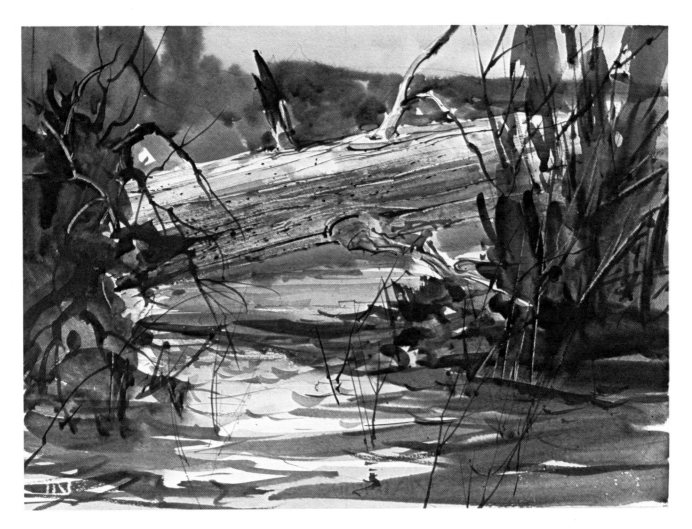

Step 7. Now a small round brush comes into play for the final textures and details. Drybrush strokes are run along the treetrunk, and slender lines define cracks and branches more distinctly—these darks are a mixture of alizarin crimson and Hooker's green. Twigs are added at the left, weeds at the right, and more weeds in the water, all with the tip of the brush. This is another case where the slender brush called a rigger does a particularly good job for those very thin strokes. Notice other touches such as the spatter on the treetrunk and the warm notes of cadmium red that are added to enliven the mass of weeds to the right. It's interesting to compare the finished painting with the pencil drawing in Step 1 just to see where the paint follows the drawing and where it doesn't. The lines of the treetrunk have been followed with considerable care. But the drawing does nothing more than indicate the *location* of the masses of weeds and the dark reflection in the water, which are brushed in so freely that the lines of the drawing disappear altogether.

Step 1. In spring, when leaves first appear on the trees, foliage is a delicate green, often with a hint of yellow—and the masses of leaves aren't as thick as they will be later on in midsummer. This spring landscape begins with a very simple pencil drawing that just indicates the general direction of the treetrunks and the overall shapes of the leafy masses. The sky is covered with a wash of yellow ochre. While this wash is still wet, ultramarine blue is painted in with a large, round brush.

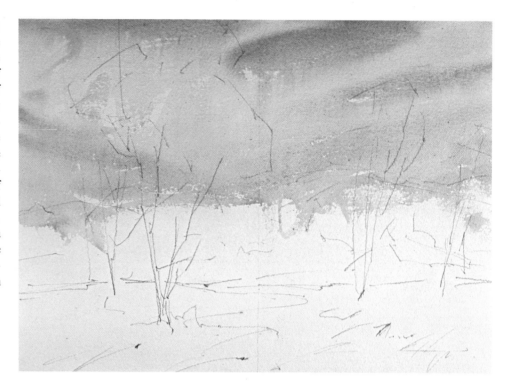

Step 2. The same brush is used to paint the distant hills with a mixture of ultramarine blue and alizarin crimson. You can see that the individual strokes vary in color: some have more blue and some more crimson. The brushwork is rough because the hills will be partially covered by a mass of trees in the next step.

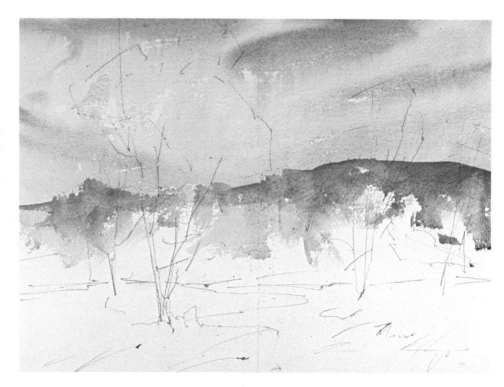

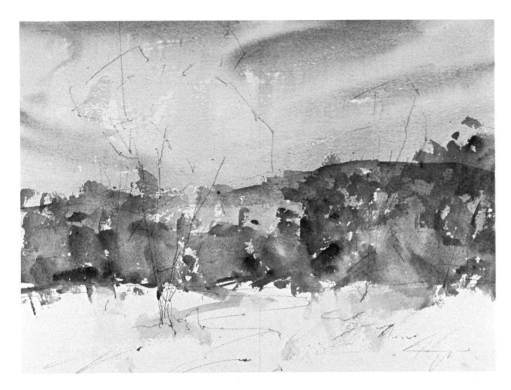

Step 3. Now the foliage in the middle distance is added with a big, round brush. The strokes are mixtures of cadmium yellow, Hooker's green, and cerulean blue. In many of the strokes, the yellow is allowed to dominate. And the strokes are applied over and into one another, fusing wet-in-wet.

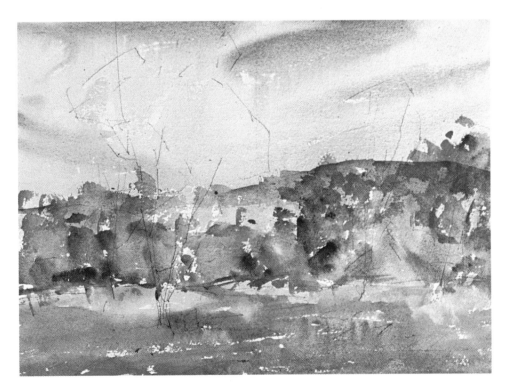

Step 4. The grass in the foreground is added with a big, round brush—the strokes are again mixtures of cadmium yellow, Hooker's green, and cerulean blue. Notice that a dark shadow has been added beneath the pencil lines of the tree on the left. In contrast with the short vertical and diagonal strokes used to suggest the trees in Step 3, the meadow is suggested mainly with long horizontal strokes.

Step 5. Now the small, round brush is used to indicate some treetrunks and branches with a dark mixture of alizarin crimson and Hooker's green. Never try to render every branch and twig. Just pick out a few. This dark tone could also be a mixture of burnt sienna and ultramarine blue, if you'd like to try a different combination.

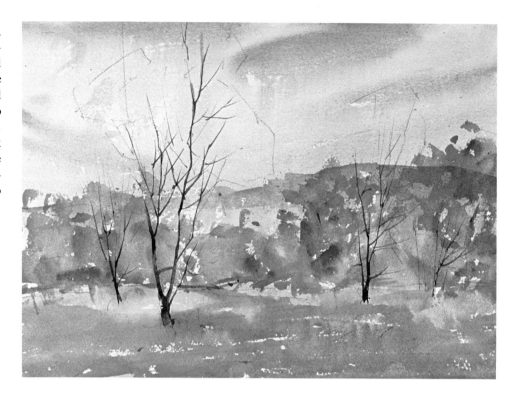

Step 6. Now, using the side of the same brush, the first foliage is drybrushed into the picture with a mixture of Hooker's green and cerulean blue, with just a hint of cadmium yellow. Working with the side of the brush, rather than the tip, you can make short, ragged strokes that are broken up by the texture of the paper, suggesting masses of leaves with patches of sky breaking through. The same method is used to drybrush a shadow under the larger tree.

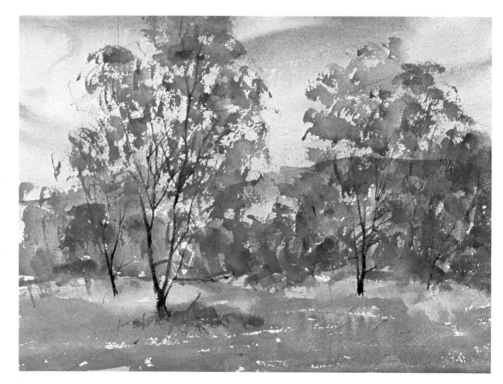

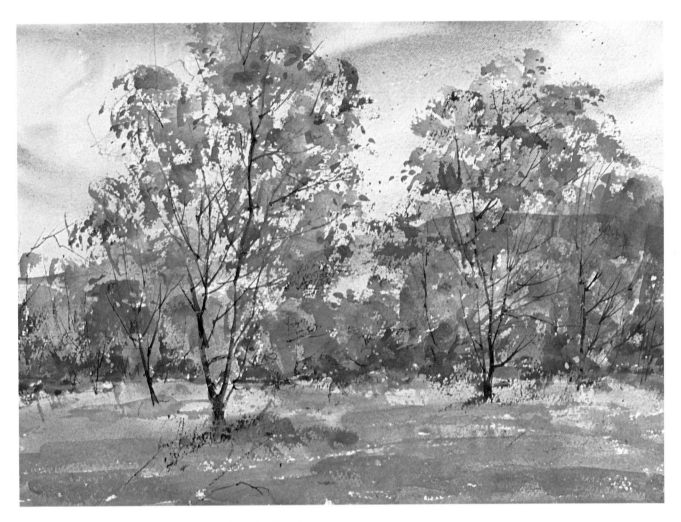

Step 7. Now, going back to a big, round brush, the picture is completed mainly with drybrush strokes—mixtures of ultramarine blue, cadmium yellow, and Hooker's green. Some darker patches are added to the trees in the foreground, suggesting shadow areas on the masses of leaves. Shadows are also suggested on the mass of trees in the middle distance, particularly along the lower edge. A shadow is suggested at the base of the tree on the right, and the shadow is darkened beneath the tree on the left. Darker horizontal strokes are added to the meadow, so there's now a gradation from dark green in the foreground to a lighter tone in the middle distance. Notice how bits of paper are allowed to show through the strokes on the ground, suggesting patches of sunlight. Some of the dark green mixture and a bit of cadmium yellow are spattered among the trees. And a rigger is used to add some more branches.

Step 1. In midsummer, trees are in full leaf and foliage tends to be darker and denser. Once again, this landscape begins with a very simple drawing, just suggesting the placement of the treetrunks, the leafy masses, some foreground shadows, and the shapes of the hills. The sky begins with a few strokes of a very pale yellow ochre, quickly followed by strokes of cerulean blue that fuse softly into the yellow. The strokes of the distant hills are mixtures of cerulean blue and cadmium orange.

Step 2. The foreground is painted with a mixture of cadmium yellow, Hooker's green, cerulean blue, and an occasional hint of cadmium orange. The same mixtures are used for the green patches between the trees in the middle distance, but with a bit more blue and green in the strokes. The patches of color between the trees are brushed in very freely, paying little attention to their exact shapes, since a great deal of the middle distance will be covered by the bigger, darker shapes of the trees.

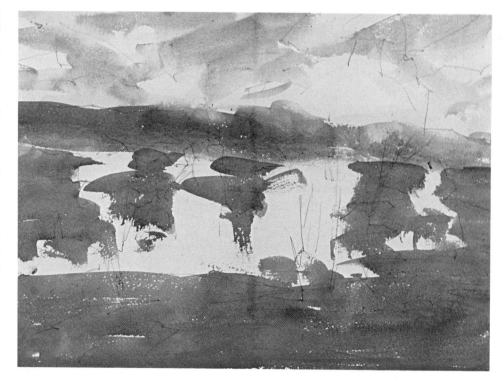

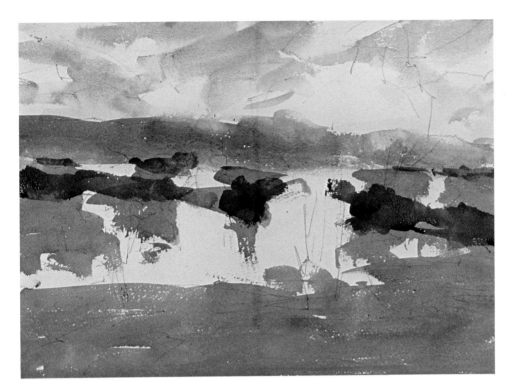

Step 3. Still working with a big, round brush, the darker patches in the middle distance are now painted with a mixture of Hooker's green and cerulean blue. You could actually use a small round brush at this point, but it's always best to use the biggest brush you can handle, since this forces you to work boldly.

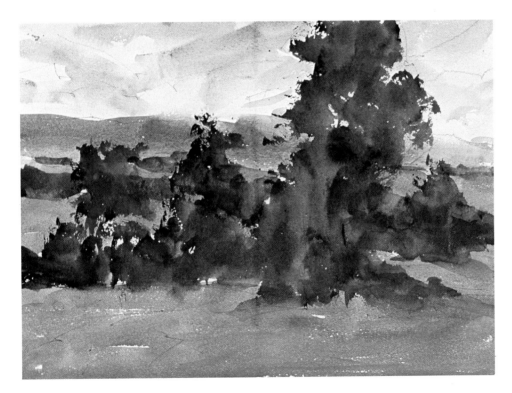

Step 4. The big masses of the foreground trees are now brushed in with a blend of Hooker's green, cadmium yellow, and burnt sienna. The darkest strokes contain more burnt sienna. The strokes are brushed over and into one another, so they tend to fuse wet-in-wet. Along the edges of the trees, the side of the brush is used so that the dry-brush effect suggests leafy edges. Where the leafy masses touch the ground, a damp brush (just water) is used to soften the transition.

Step 5. The foliage is darkened with a mixture of Hooker's green and burnt umber. Many of the leafy masses now appear to be in shadow. You can see a trunk beginning to show in the largest tree, beneath which a shadow has begun to appear. With a small, round brush, a few dark flecks are added around the edges of the trees to suggest some more leaves.

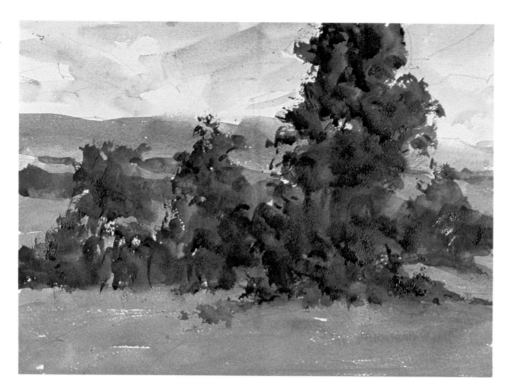

Step 6. The tree shadows in the foreground are painted with a mixture of Hooker's green and burnt sienna. The strokes curve slightly, suggesting the curve of the meadow. The sunlit patches are the wash that was applied in Step 2, which is allowed to break through the darker shadow strokes.

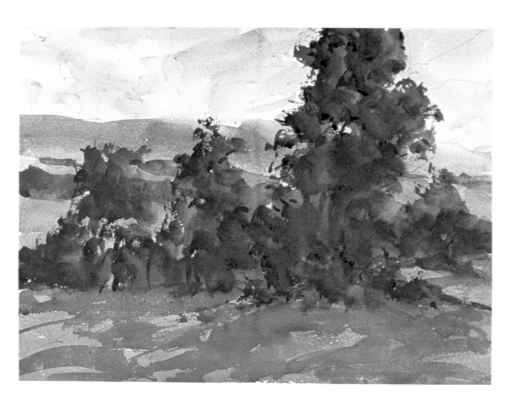

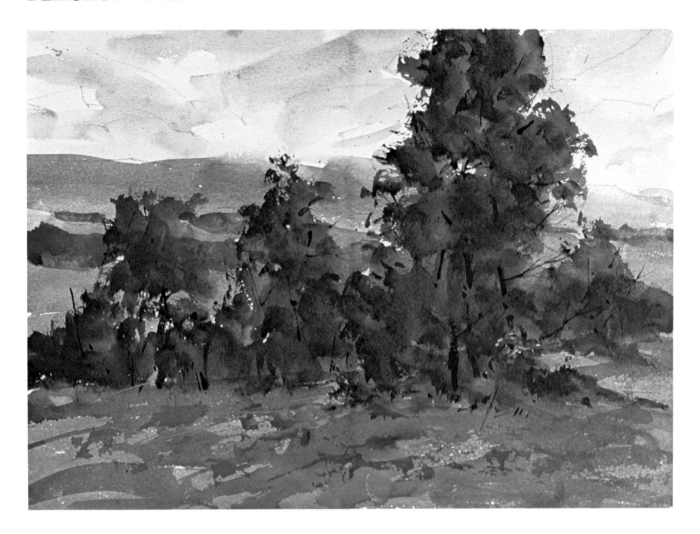

Step 7. As always, details are saved for the very end. A small, round brush is used to indicate trunks and branches among the trees. More dark strokes are added to the foreground, while the shadow under the largest tree is reinforced with some dark strokes too. Some tiny flecks of cadmium yellow are added to the grass and around the base of the largest tree. They're very unobtrusive, but they do make the painting look just a bit sunnier. This painting is a particularly good example of how few strokes you need to paint a convincing landscape. The trees consist almost entirely of large masses of color with just a few touches of a small brush to suggest trunk and branches. By the way, did you notice that the pencil lines in the sky haven't been erased? You can leave them there if you like. Or you can take them out with a kneaded (putty rubber) eraser. But wait until the painting is absolutely dry, or even this very soft eraser will abrade the surface.

Step 1. The hot colors of autumn trees look even richer if they're placed against a very subdued background such as a gray or overcast sky. So this autumn scene begins with a sky of Payne's gray, warmed with a bit of yellow ochre. The sky tone is brushed right over the pencil drawing, which will later disappear under masses of color. The distant hills are cerulean blue and a bit of cadmium red. A big sky like this can be painted quickly with a large, flat brush or a large, round brush.

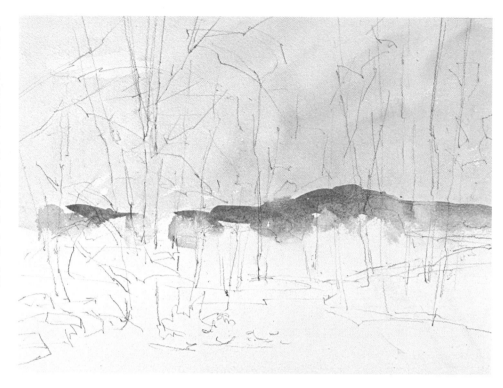

Step 2. The mass of foliage in the middle distance is painted with short strokes of a big round brush. The strokes are mixtures of cadmium orange, Hooker's green, and burnt sienna. The darker strokes contain more burnt sienna, and the hotter colors contain more cadmium orange.

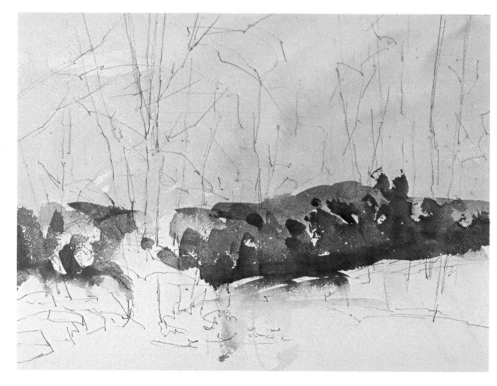

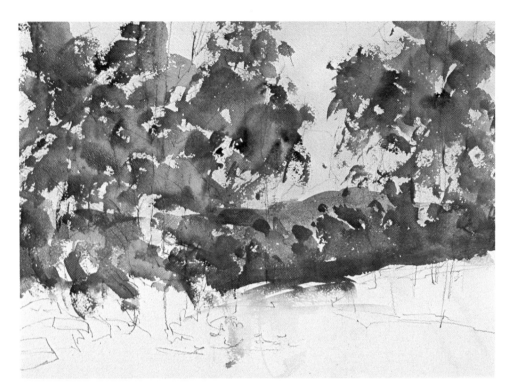

Step 3. Now the colorful masses of foliage are roughly painted with short strokes of a big, round brush. The strokes are various mixtures of cadmium yellow, yellow ochre, cadmium orange, Hooker's green, and burnt umber—never more than two or three colors in any mixture. The wet strokes tend to blur into one another. The side of the brush is often used for a dry-brush effect that suggests leaves. Notice how patches of sky break through among the strokes.

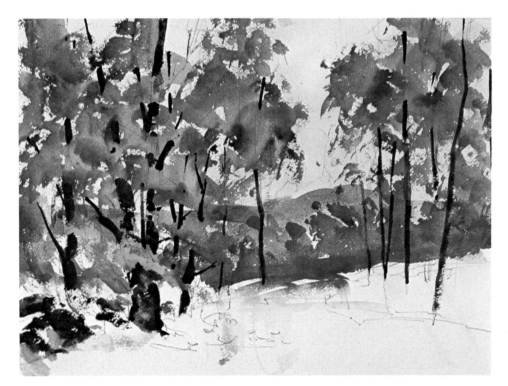

Step 4. The darks of the tree-trunks and the rocks at the left are added with a small, round brush, carrying a blend of alizarin crimson, Hooker's green, and just a touch of cadmium red. Observe how the trunks of the larger trees to the left are painted with short strokes so that the trunks are often concealed by the masses of leaves. The color on the rocks is rather thick—not too much water—so the strokes have a drybrush feeling that suggests the rough texture of the rocks.

Step 5. Going back to a big round brush, the foreground is painted with various mixtures of cadmium orange, cadmium red, alizarin crimson, and Hooker's green—never more than two or three colors to a given mixture. The darks, suggesting shadows on the ground, contain more Hooker's green. The strokes blend into one another, wet-in-wet, and curve slightly to suggest the contour of the ground.

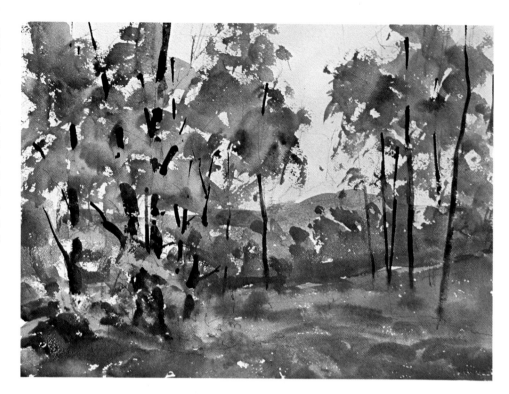

Step 6. To suggest individual leaves—some of them blowing in the autumn wind—a mixture of cadmium orange, cadmium red, and Hooker's green is spattered over the upper part of the picture with a small round brush. More trunks and branches are added with the tip of a small brush and a mixture of alizarin crimson, cadmium red, and Hooker's green, which makes a very rich dark. The tiniest branches can be done with a rigger.

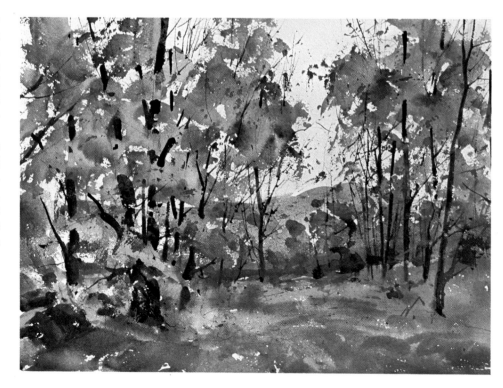

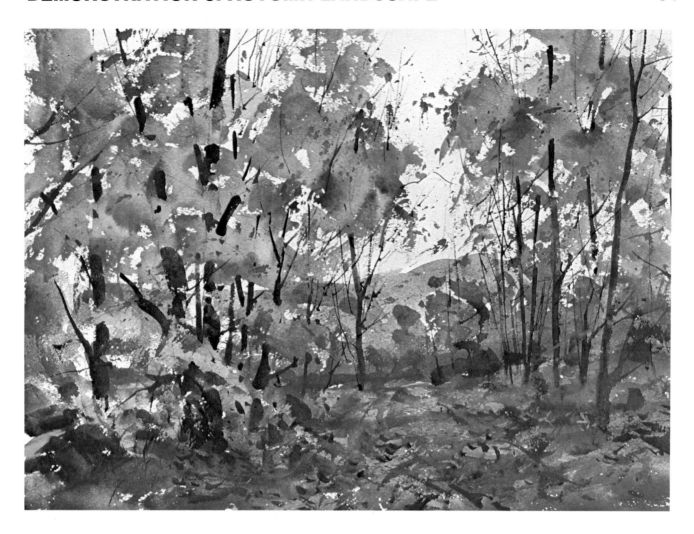

Step 7. The lively texture of the fallen leaves on the ground is suggested by drybrush strokes, made with the side of a small round brush and a mixture of alizarin crimson and Hooker's green. More touches of this mixture are added with the tip of the small brush. While the paint on the ground is still damp, some lighter areas are scratched in with the tip of the brush handle or a slender, blunt knife. If you look carefully at the ground area, all you'll see is a mass of rough brushwork and a few tiny strokes made with the tip of the brush. You don't really see any fallen leaves, but the brushwork makes you *think* you see them. Detail is suggested, never painted methodically. And look carefully at those hot autumn colors. They're not nearly as red and orange as you might think. If the whole painting were just red and orange, you'd find it terribly monotonous. You need that gray sky and those cool hints of green for relief. Besides, they make the warm colors look warmer by contrast.

Step 1. The pale tones of a snowy landscape often contrast dramatically with the dark, overcast skies of winter. The preliminary pencil drawing quickly indicates the shape of the main tree, the location of a few other trees, the shadows in the foreground, and the placement of the horizon. The dramatic cloud shapes aren't drawn in pencil, but just painted wet-in-wet. The sky begins with a pale wash of burnt sienna over the entire sky area. While this is still wet, the darker tones are brushed in—a mixture of ultramarine blue, burnt umber, and Payne's gray.

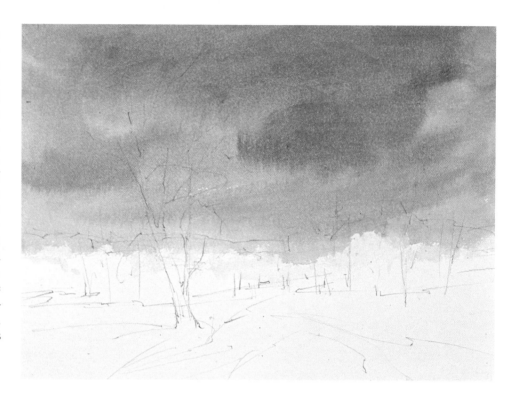

Step 2. When the sky tone is dry, the strip of landscape along the horizon is painted with a mixture of cerulean blue and burnt umber, using a small round brush. At the center of the horizon, you can see how a wet brush—just plain water—has been used to soften the dark edge to create a more atmospheric feeling.

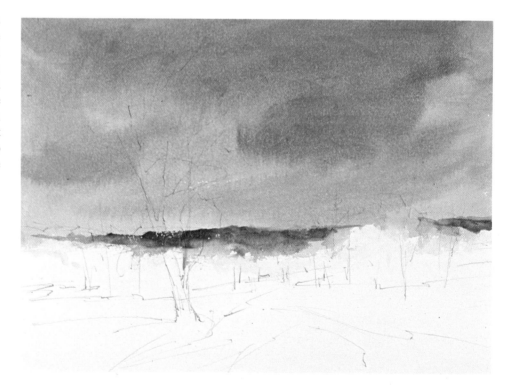

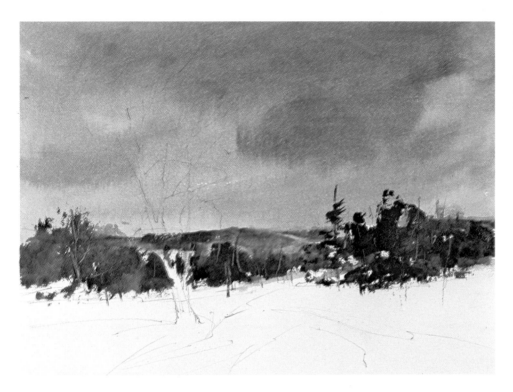

Step 3. With a blend of Hooker's green, burnt umber, and Payne's gray, the trees in the middle distance are painted with a small, round brush. The color is a bit thick—not too much water— so the paint isn't too fluid and goes on with a slightly dry-brush feeling. While the color is still wet, the tip of the brush handle scratches in some lighter lines for tree-trunks. Along the lower edge of this color area, the side of the brush is used to create an irregular drybrush texture.

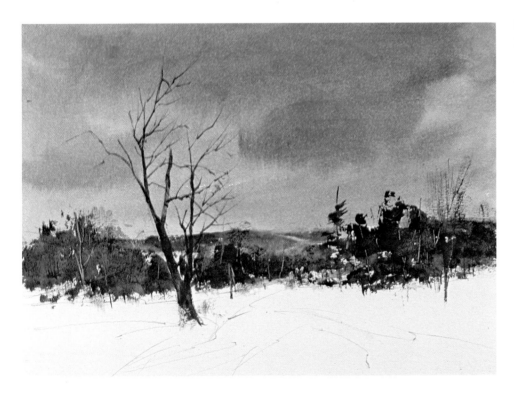

Step 4. The tall, bare tree is painted with the tip of a small round brush and a mixture of cerulean blue and burnt um-ber. The trees in the back-ground are darkened with drybrush strokes of burnt umber and Hooker's green, which are also used to suggest a smaller tree at the right.

Step 5. The variations in the color of the snow are painted with a large, round brush and very pale mixtures of cerulean blue and burnt sienna. While these strokes are still wet, some of them are softened with clear water. Thus, some of the strokes have sharp, distinct edges, while others have soft edges. This mixture is also used to indicate some pale shadows under the distant trees. Here and there, these strokes are lightened with a quick touch of the paper towel.

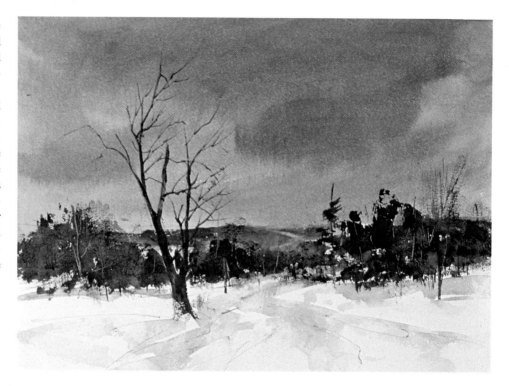

Step 6. The point of the smallest brush (or a rigger) can be used to suggest the slender lines of the dead weeds that break through the snow in the foreground. To indicate a few fallen leaves, blown by the wind, a small, round brush is used to spatter some dark specks across the foreground. These darks are all mixtures of burnt sienna and cerulean blue.

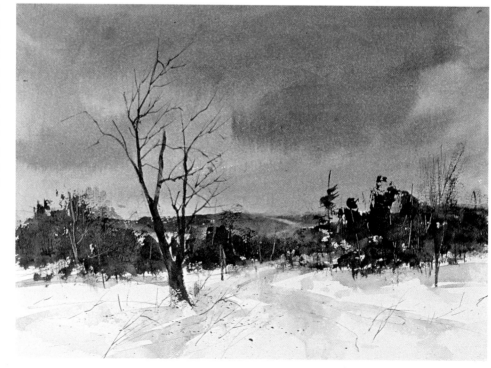

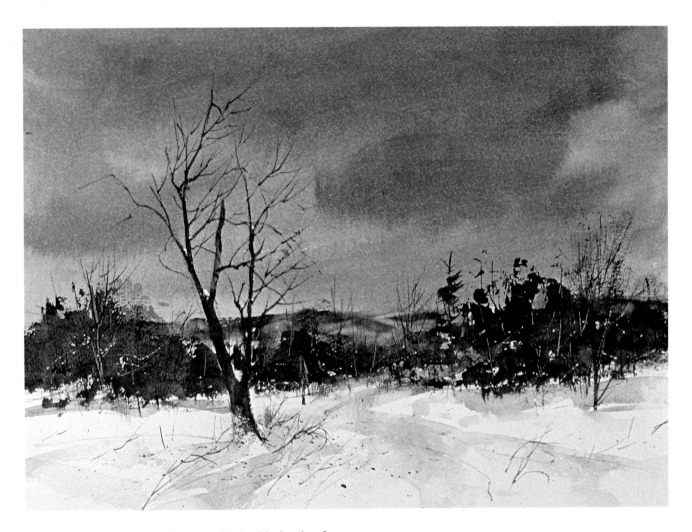

Step 7. The finishing touches are added with the tip of a small round brush. More branches appear at the tops of the trees along the horizon and on the big tree just left of center. A wet bristle brush is used to scrub out some color on the distant hills, suggesting that light is falling on them. The wet color is then blotted up with a paper towel. The corner of a sharp blade is used to scratch out a few whites on the main treetrunk, suggesting snow caught among the branches. This winter landscape is a good example of how much color you can suggest with subdued tones. The grayish sky is actually full of warm and cool color. The snow isn't a dead white, but also contains very delicate warm and cool notes. And the dark notes contain no black at all—they're actually mixtures of much brighter colors. Thus, even the darkest strokes have a hint of color.

Step 1. The forms of the distant headland, the nearby cliffs, the rocks, and the edge of the water are carefully drawn with light pencil lines. But the cloud shapes in the sky will be soft and blurry, so there's not much point in drawing them. The sky area is covered with a very pale wash of yellow ochre, applied with a big, flat brush. Then a big, round brush is used to brush long, curving strokes of ultramarine blue into the yellow ochre while it's still wet.

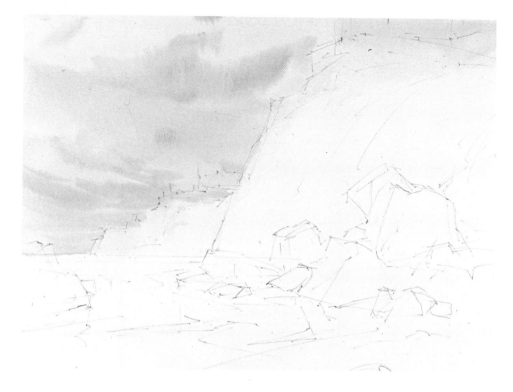

Step 2. A small, round brush is used to paint the distant headland with various mixtures of Payne's gray and yellow ochre—some pale, some dark—and some of these strokes are blotted with a paper towel while they're still wet. This use of the paper towel creates an irregular texture that suggests the roughness of the rocks and the trees at the top of the headland. These strokes will also look rougher if you use the side of the brush.

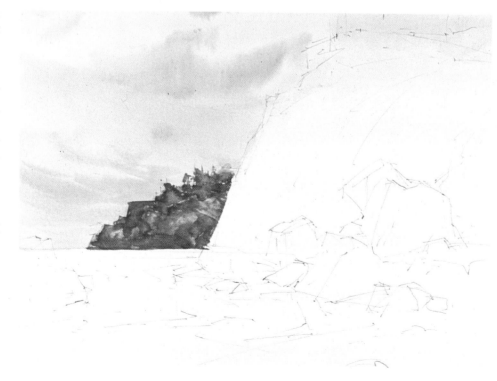

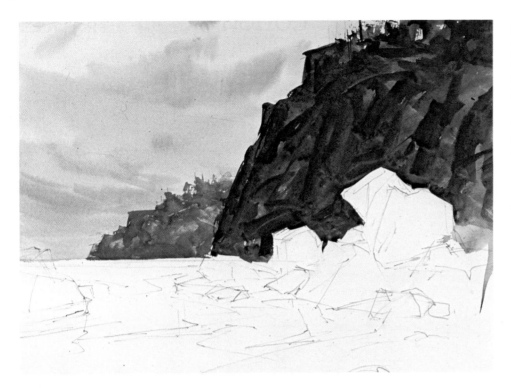

Step 3. The big, dark cliff is painted with a large, round brush and a mixture of burnt sienna, burnt umber, and Hooker's green. The darkest strokes contain very little water and are mainly burnt umber and Hooker's green. The tip of the brush is carefully worked around the shapes of the foreground rocks, following the pencil lines.

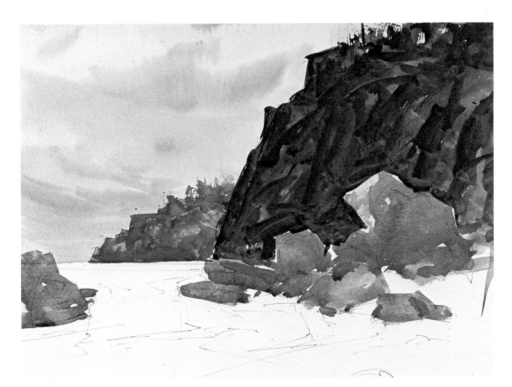

Step 4. The rocks are first painted with a pale wash of cadmium red, burnt sienna, and ultramarine blue, using a small, round brush. When this pale wash is dry, the shadow areas are painted with a mixture of ultramarine blue and burnt sienna. Notice that the strokes are very casual, leaving an occasional fleck of bare white paper to suggest a sunlit edge on the rock.

Step 5. The small, round brush is used to paint a strip of rich color in the water—a mixture of Hooker's green, ultramarine blue, and Payne's gray. More water is added to this mixture, which is carried toward the shore. At the right, the mixture is darkened with more Payne's gray to suggest the reflection of the distant headland. And a white strip of bare paper is left just under the headland to indicate light reflecting on the water. The sand is painted with a pale wash of yellow ochre and Payne's gray, plus a few strokes of Hooker's green and burnt sienna to suggest some seaweed.

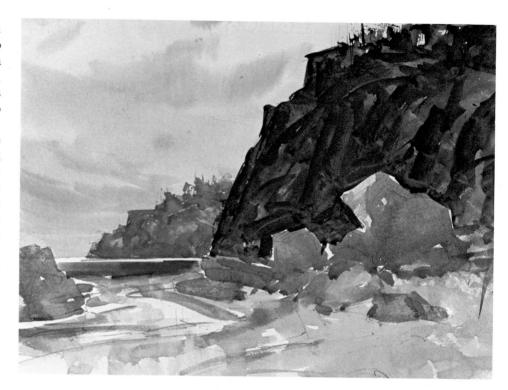

Step 6. With a small, round brush, dark shadows are painted on the rocks with a mixture of cadmium red, burnt sienna, and ultramarine blue. The strokes are sharp and distinct, not merging into one another, to emphasize the solid, blocky character of the rocks. Some smaller touches of the brush give the impression of pebbles scattered around the base of the rock formation.

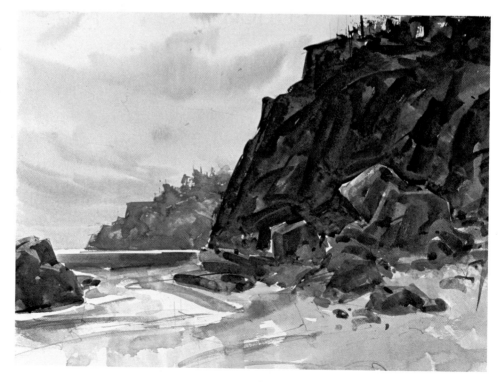

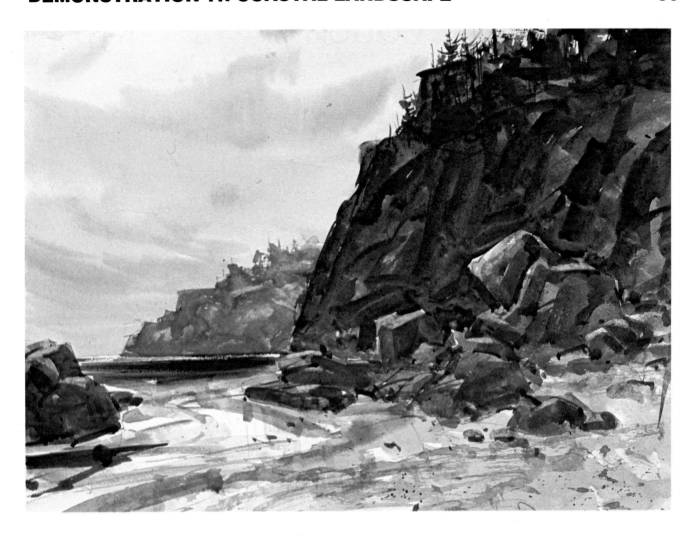

Step 7. The final touches are all put in with a small, round brush. A few trees are added at the top of the nearby cliff— a mixture of Hooker's green and burnt umber. Cracks, shadows, and other details are added to the rocks with a dark mixture of ultramarine blue, burnt sienna, and cadmium red. This mixture is used to dash in a few quick strokes for the reflection beneath the rock at the left. Free, scrubby strokes of Hooker's green and burnt umber are carried across the foreground to give the feeling of more seaweed and other beach debris. This effect is further enhanced by spattering this mixture across the sand. The distant water is darkened with ultramarine blue and a bit of burnt sienna. When this is dry, the strip of light is reinforced with a quick scratch of a sharp blade, guided by a ruler or by the straight handle of a brush.

DEMONSTRATION 12. BEACH

Step 1. The rocks on the beach are very carefully drawn to record their shapes precisely. The silhouette of the distant headland is also traced carefully. The sky is covered by a series of horizontal strokes consisting of various mixtures of yellow ochre, cerulean blue, and burnt sienna, which partially fuse, wet-in-wet.

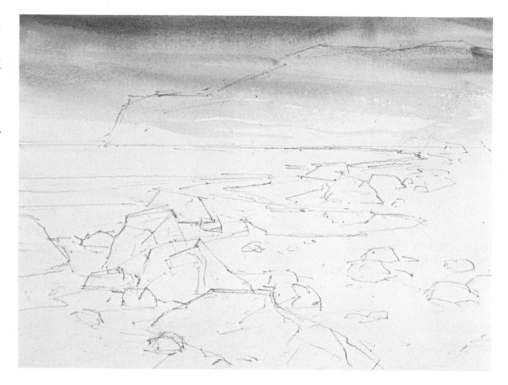

Step 2. The dark shape of the distant headland is painted with a mixture of burnt umber, ultramarine blue, and Hooker's green. Notice that it's not a smooth, even tone, but sometimes darker and sometimes lighter, depending on the proportions of the three ingredients in the stroke. At the extreme right, the lower edge of the headland is softened by pure water and fades away into the beach.

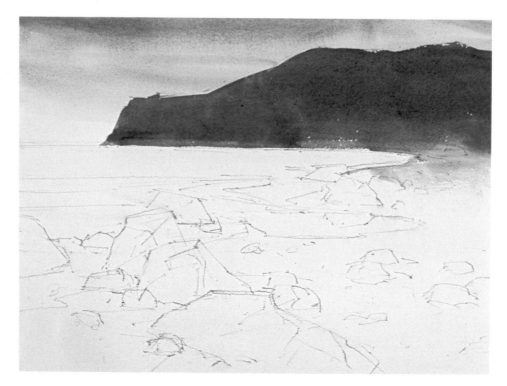

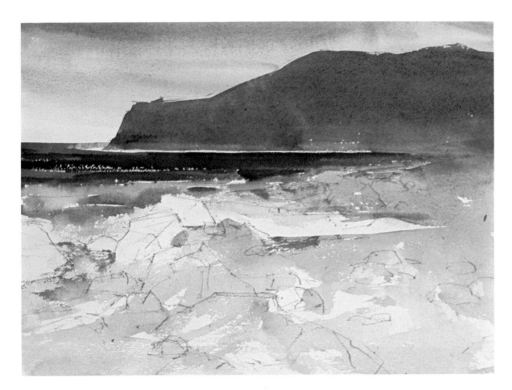

Step 3. The water is painted with ultramarine blue, Hooker's green, and burnt umber, with more water and a little yellow ochre added closer to the beach. The sand is yellow ochre, burnt sienna, and cerulean blue. The sand tone is brushed over the foreground very loosely, allowing patches of bare paper to show through. So far, everything is done with big brushes.

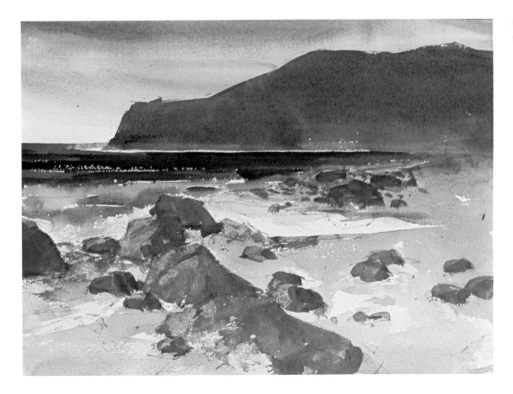

Step 4. The lighter tones of the rocks are painted with cadmium orange, burnt sienna, and cerulean blue. When these light tones are dry, the darks are added with burnt sienna, Hooker's green, and cerulean blue. The side of a small, round brush is used for the ragged textures of the rocks to the left. Now the patches of bare paper begin to look like areas of sunlight on the beach.

Step 5. With a mixture of burnt sienna, Hooker's green, and ultramarine blue, the tip of a small, round brush is used to add such dark details to the rocks as cracks, shadows, and edges. The same mixture is used to add some pebbles along the shoreline.

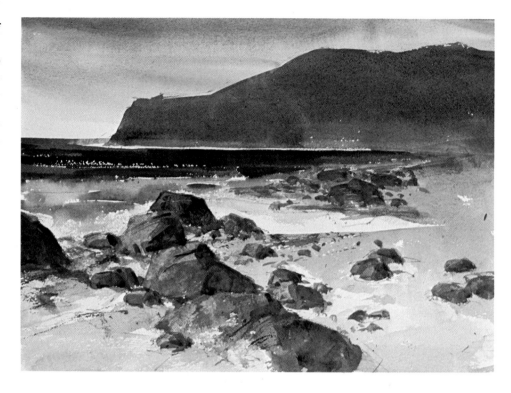

Step 6. To suggest pebbles, seaweed, and other debris, the side of a small brush is used for drybrush textures along the shoreline and in the lower left corner. Then the same brush is used to spatter dark flecks over the beach. This dark mixture is burnt sienna and ultramarine blue.

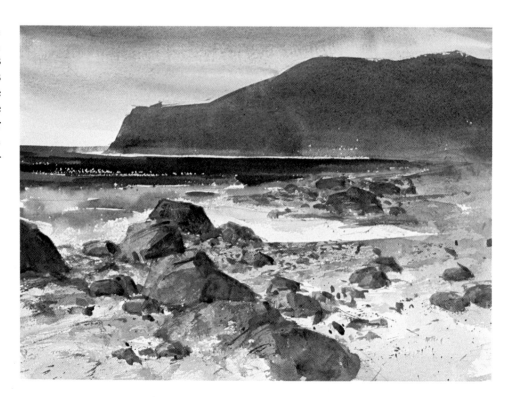

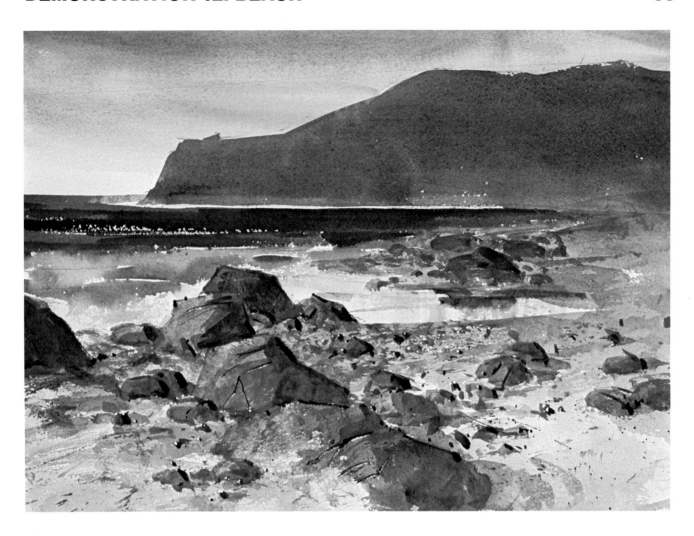

Step 7. The tip of a small, round brush and the sharp corner of a blade are used for the finishing touches. More dark cracks are added to the rocks. Then the blade is used to scratch some light lines along the cracks. The blade also picks up flecks of light on the pebbles at the edge of the water. A reflection is added in the tidepool just beneath the rock to the left of center—then blurred with clear water. Some cast shadows are added to the right of the rocks. These dark tones are mixtures of cerulean blue and burnt sienna or Hooker's green and burnt umber. Notice how bare paper has been left exposed at various stages in the painting process, creating the impression that light is flashing across the water and on parts of the beach.

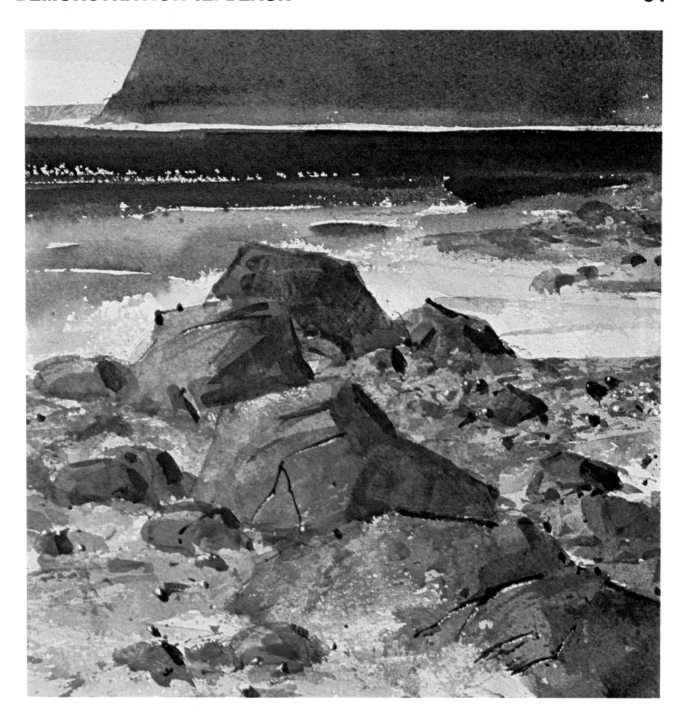

Step 7. (close-up). In this close-up of the rocks, a portion of the beach, and a portion of the water, you can see the brushwork in more precise detail. Notice how drybrush is used to suggest the sandy, pebbly texture of the beach. A dark line and a white scratch, side by side, make the cracks in the rocks look very convincing. Tiny flecks of white paper, picked off the tops of the pebbles with the corner of a blade, increase the feeling of sparkling light and shadow.

You can also see how the dark tone of the ocean is gradually lightened with more water toward the shore. If you work quickly, drawing your brush straight across the paper without pressing too hard, you can leave an occasional gap of white paper to suggest the broken strips of light across the dark water. You can also lighten the water—as in the area close to the shore—by pressing down hard with a paper towel while the color is still quite wet.

Technical Tricks. Although brushes are the primary tools of watercolor painting, watercolorists are always discovering new "technical tricks" that they can perform with other tools. Knives, razor blades, and the pointed end of the wooden brush handle are frequently used to create lines and textures. Surprising things can also be done with sandpaper, plastic credit cards, ice cream sticks, butter knives, and other implements from the kitchen or the toolbox.

Scratching Wet Paper. The easiest way to create a line, of course, is by drawing the pointed tip of your small, round brush across the surface of the dry paper. But another way is to take some pointed implement, such as the tip of the brush *handle*, and scratch into the paper while the wash is still wet. The color will settle into that groove and make a line that has a very different character from a brushstroke. The tip of the brush handle makes a sharp, slender line. A more ragged line is produced by scratching into the wet color with the tip of a sharp knife or the pointed corner of a razor blade. You'll find that these lines are always darker than the surrounding wash, so this technique is best for suggesting things such as dark branches, twigs, weeds, and grasses.

Scraping Wet Color. One of the hardest things to paint in watercolor is a light line surrounded by darker color. Because you have no opaque color, you can't paint the dark area first, then paint light lines over it. You have to paint the dark color around the light shape. However, a blunt tool such as the rounded corner of a plastic credit card, the rounded tip of a wooden ice cream stick, or the rounded blade of a butter knife will push aside a certain amount of wet color if you use the tool properly. The trick is to press the blunt instrument against the paper and push aside the wet color the way you'd scrape butter off a slice of bread—but don't dig in and create a groove, which could actually produce a darker line. Thus, you *can* create those light treetrunks by starting with a dark wash, then scraping away some lighter lines while the wash is still wet.

Scraping Dry Color. Once a wash is dry, you can use the tip of a knife or the sharp corner of a razor blade to scratch away the dried color and reveal the white paper beneath to create twigs, branches, weeds, and grasses in sunlight. Using the flat edge of a razor blade or a knife, you can also scrape away larger areas. For example, if you want to lighten the sunlit side of a treetrunk, a cloud, or a rock, you can gently scrape away *some* of the dry color so that the underly-

ing paper begins to peak through. Once you've scraped an area, don't paint over it—the fresh color will sink into the scrapes, and they'll come out darker than before!

Correcting Watercolors. By now, it should be clear that a watercolor painting is extremely hard to correct. Because your color is transparent, you can't simply cover up an unsuccessful passage with a fresh layer of paint. The underlying color always shines through. While the passage is still wet, you can blot off most of the color with a paper towel or a cleansing tissue. But once the color is dry, you can never restore the paper to its original whiteness and start again. However, there are several emergency measures for removing enough color to give yourself a second chance.

Sponging Out. A soft, silky natural sponge will often lighten a large, dried area—such as a sky. Soak the sponge in clear water until the fibers of the sponge are very soft, then work gently over the surface of the paper, washing out the sponge frequently. You can also start by brushing a wash of clear water over the offending passage, letting the water soak in a bit so the color loosens, and then working with the sponge. Don't scrub. Move the sponge very gently.

Washing Out. If the whole painting looks hopeless, the most drastic measure is to take the whole sheet straight to the bathtub and soak out as much color as you can in a tub full of cold water. Some colors will come off by themselves. Others will wash away under running tap water. Still others will need a gentle sponging. But don't be surprised if certain colors—such as alizarin crimson or phthalocyanine blue—stain the paper permanently and resist your efforts to remove them. When you've washed away all the color that will come loose, tack the wet paper to your drawing board so the sheet will stretch fairly smooth when it dries. At this point, you'll have a "ghost" of your original painting—you can rarely get out all the color—over which you can apply fresh strokes and washes, either while the paper is still wet or after it's dry as a bone.

Scrubbing and Lifting Out. The sponge and the bathtub are for large color areas, of course. To remove color from a smaller area, you can try scrubbing with a bristle brush—the kind used for oil painting. Work with the brush in one hand and a paper towel or cleansing tissue in the other. Dip the brush in clear water, scrub gently, and blot away the loosened color with the towel or tissue.

Step 1. If you want to make dark lines by scratching into wet color, you've got to work quickly. Let's say you want to add many little branches amid the foliage of a tree. Paint the large masses of the leaves rapidly with a sopping wet brush

Step 2. While the masses of leaves are still wet and shiny, scratch into them with the corner of a sharp knife or razor blade. Make sure you abrade the surface so the dark color flows into the lines, which then become darker than the surrounding foliage. You can see many little lines scratched into the foreground tree and the other trees along the horizon. Then you can add more branches along the edges with the tip of a small, round brush.

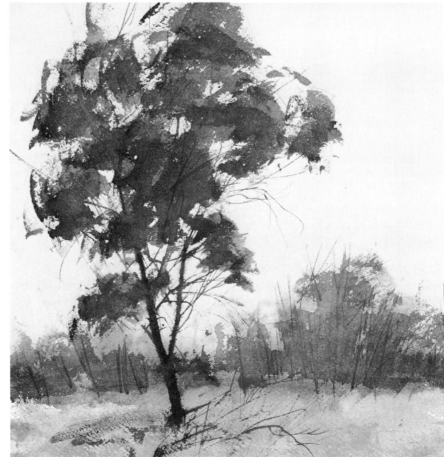

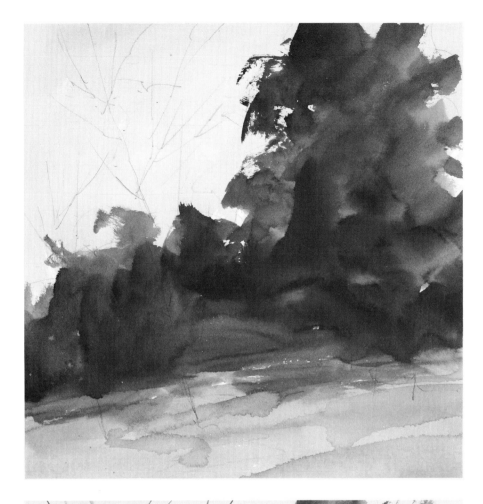

Step 1. You can also scrape *light* lines out of wet color. Once again, fill your brush with lots of liquid color and paint the big masses very quickly. Don't let them dry!

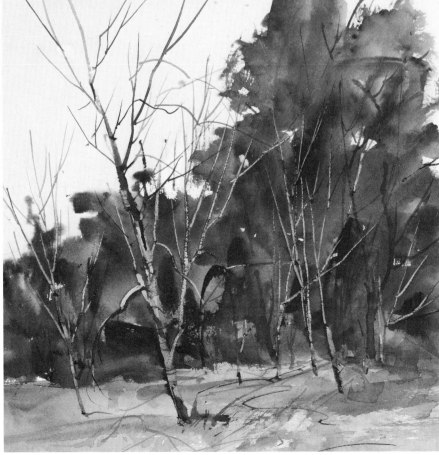

Step 2. With a slightly blunt knife, the tip of your brush handle, or the corner of some improvised tool like a plastic credit card, you can scrape away the light lines of the trunks and branches against the dark background. Now you're not digging into the paper and abrading it, but simply *pushing the color aside*. Then you can use a small, round brush to paint the darker branches.

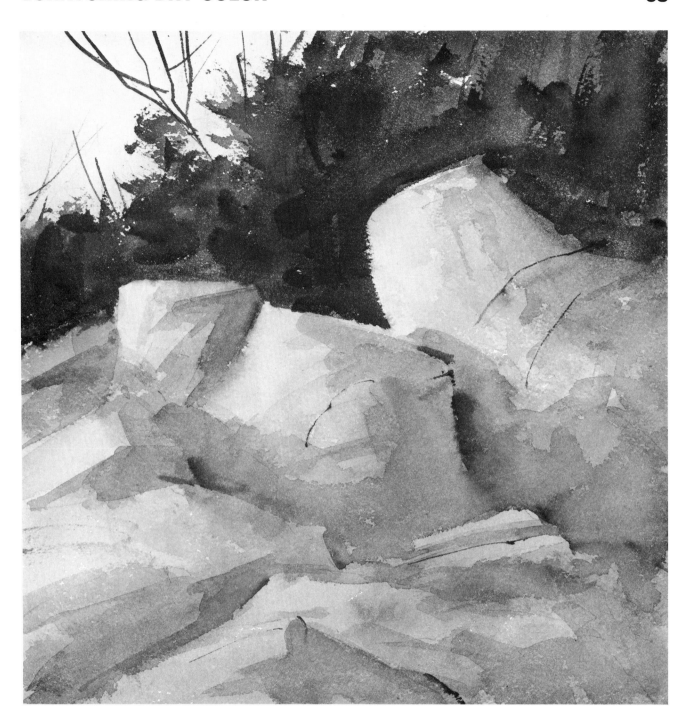

Step 1. Another way to add light details against a dark background—and to lighten broad areas—is to scratch or scrape away color when the painting is dry. Here you see the broad shapes of a rock formation and a mass of distant foliage painted in broad strokes, with very little attention to detail. The rocks need more contrast between the light and shadow areas. And the foliage needs to be enlivened with some interesting detail. When you're sure the painting is absolutely dry, reach for a razor blade or a sharp knife.

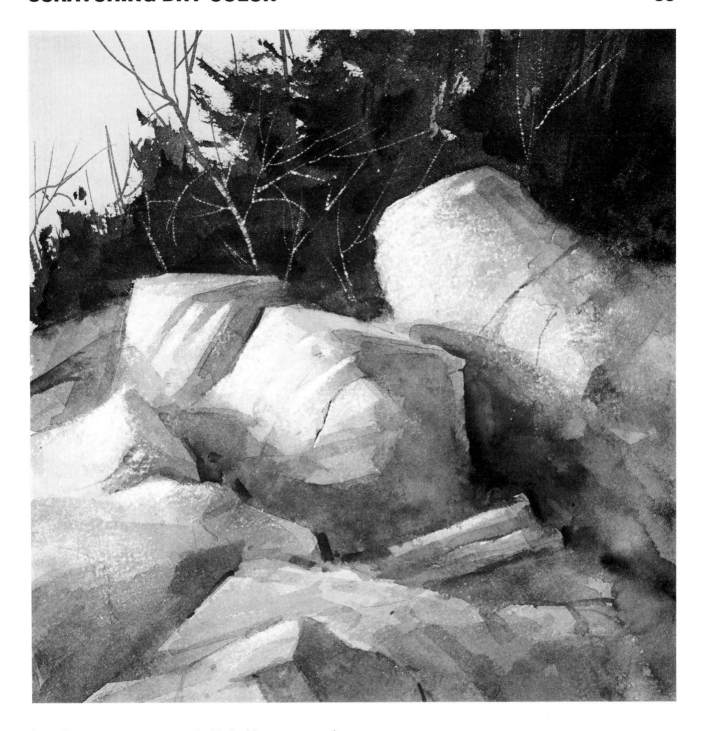

Step 2. With the sharp corner of a blade, it's easy to scratch away the light twigs and branches among the foliage at the top of the picture. If you don't scratch too hard, the blade will skip along the ridges of the paper, leaving a slightly broken white line that contains some flecks of the underlying color, like the lines you see here. If you dig in harder, you'll expose pure white. Next, the edge of the blade (not the corner) is used to scrape away the sunlit patches on the left sides of the rocks. The blade doesn't scrape the paper down to pure white, but takes off just enough color to lighten the tone and expose some irregular flecks of paper. Now you can strengthen the contrast even more by darkening the shadow sides of the rocks and adding some dark edges where one rock butts up against another.

Step 1. This sky is terribly uninteresting. It's too pale. The one distinct cloud shape is right in the middle, like a bulls-eye. Try again.

Step 2. With a silky natural sponge, you can take out most of the sky tone if you work gently. Soak the sponge until it's very soft and very wet, then gradually work across the sky with gentle strokes, wetting and removing the color. Squeeze out and rewet the sponge frequently as you work. You won't get down to bare white paper, but the sky will be light enough to repaint.

Step 3. Having sponged out a fair amount of dark color, you can let the water evaporate and go back to work on the dry paper—or you can paint right into the wetness. Here, a new sky is begun with a few strokes painted right onto the wet surface, so they begin to look like new cloud shapes.

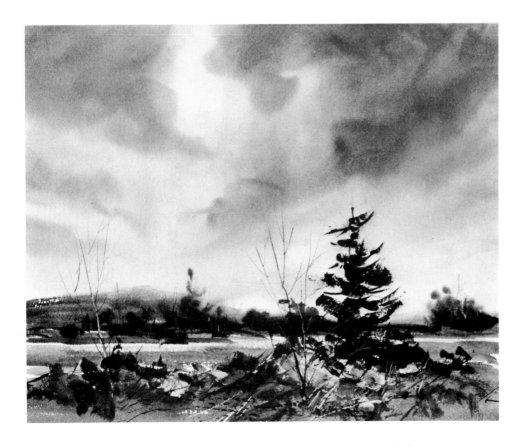

Step 4. More darks are now added to the wet surface with big, bold strokes, and new, more dramatic cloud shapes emerge. To create a few light patches where the sun seems to shine through, some of the darks are blotted away with a wad of paper toweling.

Step 1. This painting is dull because the darks are evenly scattered all over the sheet. The distant landscape looks too close because it's just as dark as the foreground. And the water lacks delicacy. How can this be corrected?

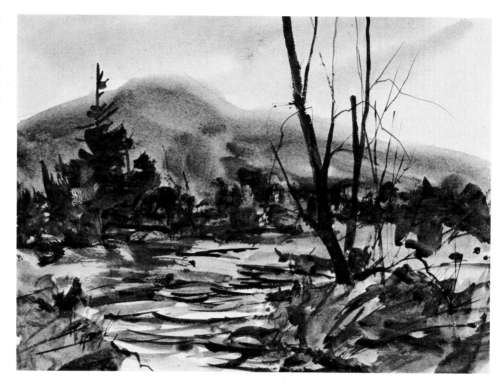

Step 2. You can take the whole painting straight to the bathtub. Fill the bottom of the tub with cold water and soak the painting until the color begins to lift off. You can speed up the process by working over the sheet gently with a natural sponge. You can also try running the sheet under the tap. You won't get off *all* the color, but you'll remove enough to try again.

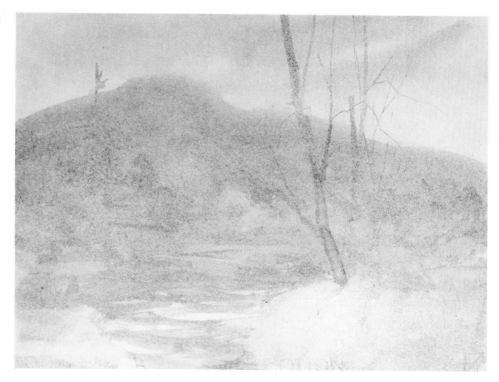

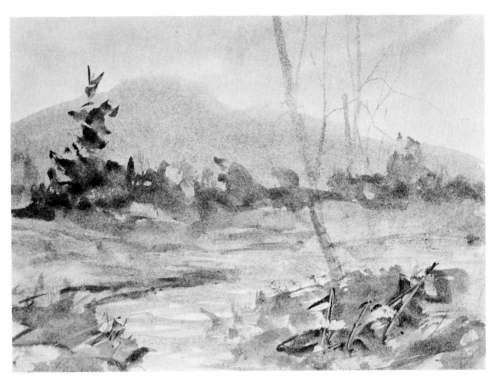

Step 3. To create a sense of deeper space and atmosphere, you can leave the "ghost" of the distant mountain and paint the trees in the middle distance with light strokes. Then you can begin to strengthen the darks in the foreground.

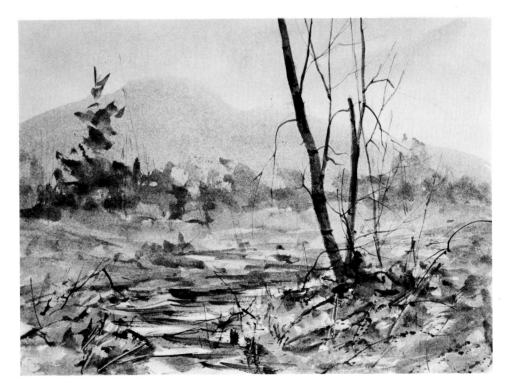

Step 4. Now you can concentrate on repainting the foreground—darkening the tree, foliage, and nearby water just enough to make them come forward in space, while the water and trees in the middle distance stay back. Quit while you're ahead. Don't overdo it or you'll be back at Step 1.

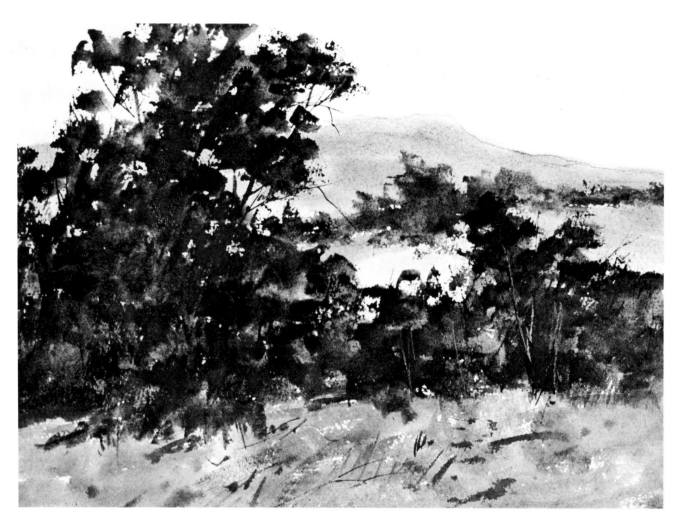

Step 1. These trees have gotten so dark that the trunks have disappeared, and the foliage forms a monotonous mass without enough detail. How can you go about adding some lighter treetrunks to relieve the monotony. You could, of course, try scratching some light lines into the darkness. But there's another solution that you might also like to try.

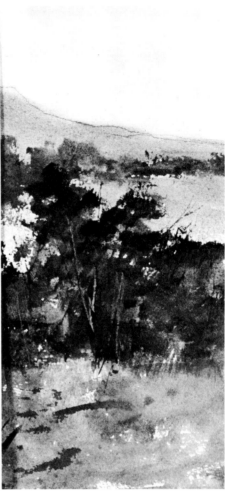

Step 2. Make a careful drawing of the shapes of the trunks on a separate sheet of sturdy white paper or thin cardboard. Then take a sharp blade and cut away the trunks, leaving gaps in the paper where the drawing of the trunks used to be. Now you've got a kind of stencil that you can place over the painting and tape down with some slender strips of masking tape—which you can see across the biggest trunk and the one to the left. The tape will hold the stencil snug against the paper.

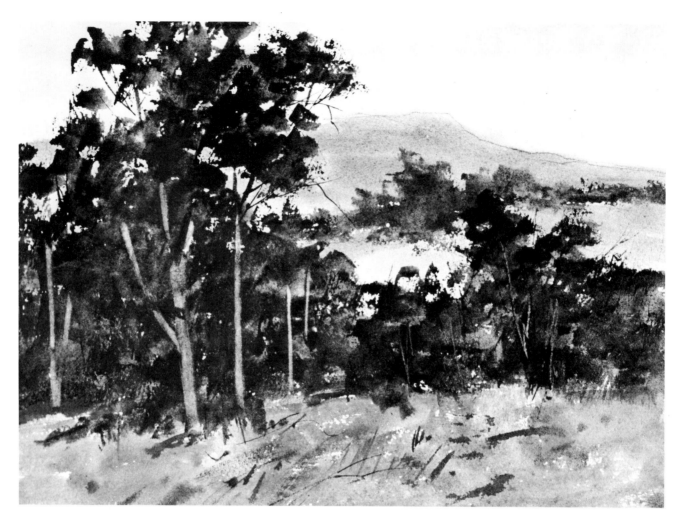

Step 3. Wet a small, stiff bristle brush—the kind used for oil painting—and carefully scrub away the dark color that shows through the gaps in the stencil. As you scrub, blot off the wet color with a wad of paper toweling. Be sure to rinse the brush frequently, so you're always working with clear water. Don't use so much water that the liquid color runs under the edges of the stencil. Use just enough water to loosen the color and then blot it up with the paper towel. When you peel away the stencil, the painting will have light lines like those you see at the left of the picture. They don't look like treetrunks just yet, but now you've got strips of lighter paper to work on. Let the corrected areas dry before you do any further work.

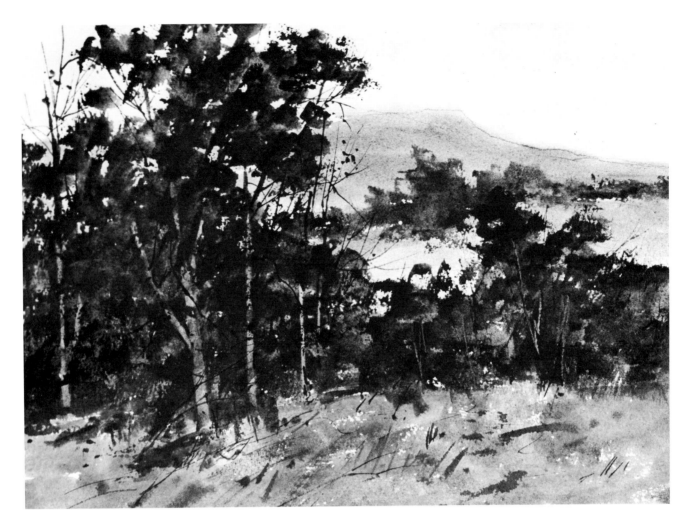

Step 4. Now you can go back to work with a small round brush and turn those pale strips into treetrunks. You can add darks around the edges of the trunks to give them exactly the right shape. You can obliterate some portions of the light strips to suggest shadows and foliage crossing the trunks. A bit of drybrushing will add texture. You can also "anchor" the trunks more firmly to the ground by suggesting some shadows below. And you can extend the new trunks upward into the sky with dark strokes. Now you have a convincing mass of trees, interrupted by lighter trunks and branches.

Step 1. The dark streaks across the center of this picture are supposed to represent distant hills, but they're too dark and they don't look distant enough.

Step 2. You can lighten the tops of the hills—making them fade away into the distance—by scrubbing them with a big, wet bristle brush. As you scrub and loosen the color, blot it away with a paper towel. Keep rinsing the brush so that it removes color rather than spreading it around. When the hills are dry, you can then paint the trees in the foreground. Now the hills look really far away.

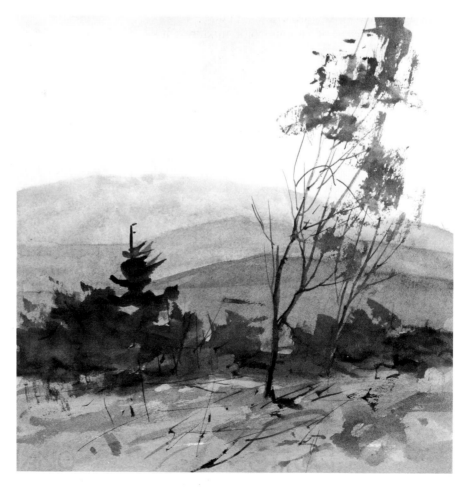

Developing Good Habits. After the excitement of painting, it's always a letdown to have to clean up. Fortunately, you can clean up quite quickly after painting a watercolor—the job takes a lot longer if you're working in oil. It's essential to develop the right cleanup habits, not merely to keep your studio looking shipshape, but because the watercolorist's tools and equipment are particularly delicate and need special care. Here are the most important steps in your cleanup. Don't neglect them!

Sponging. After a day's painting, you'll certainly leave little pools and spatters of color in all sorts of odd places. Your drawing board or drawing table will have a fair amount of dried color around the edges, which you should sponge away with an ordinary household sponge. (Don't waste an expensive natural sponge on this task.) If you don't sponge off your drawing board and other work surfaces, there's always the danger that some of this color will dissolve and work its way onto the fresh white paper during your *next* painting session. You should also sponge off the color that's accumulated on the mixing surface of your palette, since you obviously want to start with a fresh surface the next time you paint. There's no need to wash away what's left of the little mounds of tube color around the edges of the palette; at your next working session, you can simply wet them and use them again. However, these little mounds often get covered with traces of various color mixtures; it's a good idea to wash away these mixtures with a brush, exposing the original pure color.

Washing Brushes. Your most fragile and most expensive tools are your brushes. These take very special care. At the end of the painting day, be sure to rinse each brush thoroughly in clear water—not in the muddy water in the jars. If a brush seems to be stained by some tenacious color such as phthalocyanine blue, stroke the hairs gently across a bar of soap (not laundry soap) and lather the brush in the palm of your hand with a soft, circular motion. The color will come out in the lather, except with white nylon brushes, which may stain slightly. When all your brushes have been rinsed absolutely clean, shake out the excess water and then shape each brush with your fingers. Press the round brushes into a graceful bullet shape with pointed tips. Press the flat brushes into a neat square with the hairs tapering in slightly toward the forward edge.

Storing Brushes. Place the brushes in a clean, dry, empty jar, hair end up. Leave the brushes in the jar until they're absolutely dry. You can store them in this jar unless you live in some climate where moths or other pests are a threat to natural fibers. If you're worried about moths, it's best to store the brushes in a drawer or a box. Make sure that the hairs don't press up against anything—and sprinkle mothballs or moth-killing crystals among the brushes.

Care of Paper. Watercolor paper has a delicate surface and should be carefully stored. Don't just leave a stack of unused paper out where dust can discolor it or a sweaty hand can brush up against it. Store the paper flat in a drawer, preferably in an envelope, a flat box, or a portfolio so the paper isn't battered or scraped every time it goes in or out of the drawer. Keep the paper away from moist places such as a damp basement or a leaky attic.

Care of Colors. When you're finished painting, take a damp paper towel or a cleansing tissue and wipe off the "necks" of your color tubes to clean away any traces of paint that will make it hard to remove the cap the next time you paint. Do the same inside the cap itself. There's nothing more frustrating than wrestling with that tiny cap when you're desperate for a fresh dab of color, halfway through a painting. Also wash away any paint that might cover the label on the outside of the tube, so you can quickly identify your colors. Searching for the right color among all those filthy tubes can be just as maddening as wrestling with the cap. By the way, you'll get more color out of the tube—and save money—if you always squeeze the tube from the very end and roll up the empty portion as you work.

Safety Precautions. Be especially careful about putting away sharp instruments—and always keep them in the same place. If you bought a knife with a retractable blade, as suggested earlier, be sure to retract the blade before you store the knife in the darkness of your paintbox or toolbox. You don't want that sharp blade waiting for you when you grope around for the knife. Keep razor blades in a small envelope or in a box—or just wrap a piece of tape over the sharp edge. Keep pushpins or thumbtacks in a little envelope or box—or simply push them into the edges of your drawing board. Finally, there's always a certain amount of color on your fingertips while you're painting, so don't smoke or eat while you work. Keep those colors out of your digestive tract.

Permanence. A watercolor painting, properly taken care of, should last for centuries. Although the subject of framing, in particular, would take a book in itself, here are some suggestions about the proper way to preserve finished paintings.

Permanent Materials. It's obvious that you can't paint a durable picture unless you use the right materials. All the colors recommended in this book are chemically stable, which means that they won't deteriorate with the passage of time and won't produce unstable chemical combinations when blended with one another. When you buy other colors, either to expand your palette or to replace one of these eleven colors, study the manufacturer's literature to make sure that you're buying a permanent color. All the good color manufacturers have charts which tell you, quite frankly, which colors are permanent and which colors aren't. For the same reason, it's important to buy the best mouldmade or handmade paper. Although few papers are now made of rags, the manufacturers still use the phrase "100% rag" to designate paper that is chemically pure—and that's what you should buy once you feel that your paintings are worth saving. Lower grade papers will yellow and discolor with the passage of time.

Matting. A mat (which the British call a mount) is essential protection for a watercolor. The usual mat is a sturdy sheet of white or tinted cardboard, generally about 4″ (100 mm) larger than your painting on all four sides. Into the center of this board, you cut a window slightly smaller than the painting. You then "sandwich" the painting between this mat and a second board, the same size as the mat. Thus, the edges and back of the picture are protected and only the face of the picture is exposed. When you pick up the painting, you touch the "sandwich," not the painting itself.

Boards and Tape. Unfortunately, most mat (or mount) boards are far from chemically pure, containing corrosive substances that will eventually migrate from the board to discolor your watercolor paper. If you really want your paintings to last for posterity, you've got to buy the chemically pure, museum-quality mat board, sometimes called conservation board. The ordinary mat board does come in lovely colors, but you can match these by painting the museum board with acrylic colors. Paint both sides to prevent warping. The backing board can be less expensive "rag-faced" illustration board, which is a thick sheet of chemically pure, white drawing paper made with a backing of ordinary cardboard. Too many watercolorists paste their paintings to the mat or the backing board with masking tape or Scotch tape. Don't! The adhesive stays sticky forever and will gradually discolor the painting. The best tape is the glue-coated cloth used by librarians for repairing books. Or you can make your own tape out of strips of discarded watercolor paper and white library paste.

Framing. If you're going to hang your painting, the matted picture must be placed under a sheet of glass (or plastic) and then framed. Most watercolorists prefer a simple frame—slender strips of wood or metal in muted colors that harmonize with the picture—rather than the heavier, more ornate frames in which we often see oil paintings. If you're going to cut your own mats and make your own frames, buy a good book on picture framing, which is beyond the scope of the book you're now reading. If you're going to turn the job over to a commercial framer, make sure he uses museum-quality mat board or ask him to protect your painting with concealed sheets of rag drawing paper inside the mat. Equally important, make sure that he doesn't work with masking tape or Scotch tape—which too many framers rely on for speed and convenience.

What to Avoid. Commercial mat boards come in some dazzling colors that are likely to overwhelm your painting. Whether you make your own mats or have the job done by a framer, avoid the garish colors that call more attention to themselves than to your picture. Try to find a subdued color that "stays in its place" and allows the painting to occupy center stage. Resist the temptation to glue your finished painting down to a stiff board, even if the painting is a bit wavy. The painting should hang free inside the "sandwich" of mat and backing board, hinged either to the mat or the backing by just two pieces of tape along the two top corners of the picture. When you do hang the picture, keep it away from damp walls, leaky windows, leaky ceilings, and windows that will allow direct sunlight to pour onto the picture. Any painting—whether watercolor, oil, acrylic, or pastel—will eventually lose some of its brilliance with prolonged exposure to strong sunlight.

Storing Unframed Pictures. Unframed pictures, with or without mats, should always be stored horizontally, never vertically. Standing on its end, even the heaviest watercolor paper and the stiffest mat will begin to curl. Store these just as you'd store sheets of watercolor paper: in envelopes, shallow boxes, or portfolios kept flat in a drawer or on a shelf. Take proper care of your paintings and people will enjoy them for generations to come.